CRITICAL
AESTHETIC
PEDAGOGY

This book is part of the Peter Lang Education list.
Every volume is peer reviewed and meets
the highest quality standards for content and production.

PETER LANG
New York • Washington, D.C./Baltimore • Bern
Frankfurt • Berlin • Brussels • Vienna • Oxford

Yolanda Medina

CRITICAL
AESTHETIC
PEDAGOGY

*Toward a Theory of Self
and Social Empowerment*

PETER LANG
New York • Washington, D.C./Baltimore • Bern
Frankfurt • Berlin • Brussels • Vienna • Oxford

Library of Congress Cataloging-in-Publication Data

Medina, Yolanda.
Critical aesthetic pedagogy: toward a theory
of self and social empowerment / Yolanda Medina.
pages cm.
Includes bibliographical references.
1. Critical pedagogy—United States.
2. Art in education—United States. I. Title.
LC196.5.U6M44 370.11'5—dc23 2012012935
ISBN 978-1-4331-1736-7 (hardcover)
ISBN 978-1-4331-1735-0 (paperback)
ISBN 978-1-4539-0860-0 (e-book)

Bibliographic information published by **Die Deutsche Nationalbibliothek**.
Die Deutsche Nationalbibliothek lists this publication in the "Deutsche
Nationalbibliografie"; detailed bibliographic data is available
on the Internet at http://dnb.d-nb.de/.

Cover photograph by Stephanie Gonzalez

The paper in this book meets the guidelines for permanence and durability
of the Committee on Production Guidelines for Book Longevity
of the Council of Library Resources.

Printed in the United States of America

This book is dedicated to my family—my mother *Nori*, my grandmother *Beba,* and my aunt *Nercy*—for your unconditional love and for believing in my intellectual capacity; to Miguel Faura, my life partner, for everything—but most importantly for creating an environment in our home that allows me to think, question, and write; to Maria Fernanda, my goddaughter, my soul daughter, and my best friend, for sticking with me through thick and thin; and to the founding members of the Santo Rico Kids Cultural Center, for allowing me the opportunity to share with you my love for the arts and for our culture. Finally, to Tiffany (1994–2012) and Lucia, our family pets, for hanging out by my side while I wrote for long hours at a time.

This is for you all.

CONTENTS

FOREWORD

For a teacher, there are few rewards more satisfying than having the opportunity to share in some small way in the success of a former student; thus, being asked to write a foreword to Jolie Medina's first book is extremely gratifying. Jolie Medina was my student at Western Carolina University in the mid-1990s. I was immediately impressed with her intellect and curiosity; she stood out as different from the other students. Her willingness to ask hard questions and not accept easy answers was exciting to me as a teacher. Rather than being threatened by critical theoretical paradigms and the writings of Freire, Giroux, hooks, Kincheloe, Ladson-Billings, and McLaren, she got "it"; she understood how this body of work transformed the language we use and the ways that we talk about the work we do in schools. Of course, to understand my excitement, you have to keep in mind that as a teacher I regularly encountered student resistance to the ideas that we were considering in my classes, or as one student wrote on an end-of-class evaluation, "I didn't know I was signing up for Liberalism 101." So, while I was familiar with being regularly challenged by students who disagreed with a critical ideology, I was not accustomed to having a student who immediately shared my commitment to social justice and a desire to go out and change the world by challenging the dominant paradigms that guided teaching and learning in American schools and classrooms.

As I got to know Jolie Medina better, both personally and professionally, I realized that she was a perfect candidate for a doctoral program in education; I strongly encouraged her to continue her academic pursuits. Even then, I was confident that her perspective and experiences would inform her research and practice in important ways. As a strong, passionate, Latino woman who had spent her life bridging the gaps between two very different cultures, she had regularly confronted issues related to social class, gender, and stereotypes that most of us merely read and talk

about in our work. Jolie, however, was using her academic studies as a platform for her quest to find a theoretical framework that would help her make sense of her experiences. There was a real need for this kind of "voice" in the field of education. I was hopeful that Jolie would persevere.

Through the years, Jolie and I lost contact, but I knew that she had gone on to get her doctorate at the University of North Carolina, Greensboro. And then last spring, 2011, fate brought us together again. In her initial email to me, Jolie said the following:

> *Do you remember me? I took two classes with you during my master's degree. You taught me about Critical Pedagogy, you made me fall in love with it, and you were very supportive when I decided to go for my Ph.D. You also referred me to Svi Shapiro who then became my mentor and my dissertation chair.... As you see, I am teaching at BMCC/CUNY. This is the only community college in Manhattan, and the most diverse community college in the US. I teach foundations of Education, and coordinate the childhood and bilingual childhood programs. My students all become great passionate teachers, and most of them become very active in their schools and communities. They tell me that my biggest influence is that I teach them to love teaching in diverse environments, again this is all you.*

Her email was like a rush of fresh air. Through the years, I think that most teachers have occasion to wonder if their teaching has made a difference to anyone. With Jolie's message, however, I sat back and considered for a moment that maybe I had made a difference; maybe I had, on occasion, succeeded in getting my message across to someone. Her email was the "shot" of inspiration that I needed at that moment, but more importantly, I felt an incredible degree of pride in her professional accomplishments, and my pride increased as I read this book.

This book comes at an important juncture in time as we consider both the successes and failures of American education. For the first time in our history, we are daily confronting the evidence that our schools are regularly failing to meet the most minimal educational needs of increasingly diverse groups of students. Efforts at increased accountability through high-stakes testing have only served to highlight the shortcomings of a "one

size fits all" education. The documentary, *Waiting for Superman* (2010), produced by filmmaker Davis Guggenheim, proposed that we actually do know how to teach children regardless of their diverse backgrounds, and yet, with the exception of small pockets of educational innovation, we don't do it. Critics of the film focused on the bias toward charter schools and the anti-teacher union message in the film, but I found it most interesting that while the film highlighted the importance of excellent teachers in school reform, it did not discuss what I consider to be the foundation of the work of excellent teachers in 21st-century schools: a philosophy or vision that informs the work of teachers who are doing what Mary Cowhey, in *Black Ants and Buddhists* (2006), describes as "thinking critically and teaching differently." Indeed, a different way of thinking about teaching and learning is a prerequisite to improved schools and classrooms. In this book, Jolie Medina proposes a different way of thinking critically and teaching differently through Critical Aesthetic Pedagogy.

In Medina's book, we are presented with a theoretical framework for understanding the elements of a transformative philosophy that can guide teachers seeking to create in their classrooms a space where personal history and a focus on the arts combine to produce a pedagogy that is appropriate and relevant to the lives of students from diverse backgrounds. Personal and professional experiences both as a teacher and a learner form the foundation for Medina's description of "Critical Aesthetic Pedagogy." Coming at a time when the role of the arts in education is being marginalized in favor of an increasingly more rigorous academic focus, Critical Aesthetic Pedagogy has an important place in a reconsideration of educational spaces that foster the success of ALL students. Grounded in critical theory, Critical Aesthetic Pedagogy represents an intersection of vision and philosophy where personal history plays a key role in the lives of teachers and students. Critical Aesthetic Pedagogy challenges traditional understandings of curricula by focusing on the experiences, needs, and interests of teachers and students in educational settings that are characterized by fluidity rather than the rigidity of pacing guides and tests.

In the practice of Critical Aesthetic Pedagogy, the emphasis is on the substance and process of "real" learning: learning that has relevance to the lives and experiences of both students and teachers. Within this context, the teacher/student relationship is described by Medina as follows: "I see this form of pedagogy as a dance. The teachers and students are like dance partners in constant graceful movement, and the curriculum shifts with every encounter depending on the students' needs, interests, and experiences, and the ways in which they understand the world" (Chapter Two). Drawing upon the experiences of this author as both a dancer and a learner, Critical Aesthetic Pedagogy leads the reader to seriously consider how the infusion of the arts into schools and classrooms may provide an impetus for the articulation of a curriculum that empowers learners and recognizes the important role of a social/critical consciousness.

I frequently tell students "how we define the problem determines the solution"; we are reluctant to invest time identifying problems that are not easily solvable with quick solutions. So, while I can assert with some degree of confidence that there is no one solution to the problems associated with 21st-century schools and classrooms, I do believe that a re-consideration of the "real" problems in education is long overdue. Critical Aesthetic Pedagogy is an important effort to focus our discussions on the lived experiences of students (and teachers). And rather than merely re-scripting the pedagogies of the past, Critical Aesthetic Pedagogy provides a road map for the future—a future that looks at the roles of teachers and learners in a radically different manner. My prediction is that with this work, Jolie Medina is making her "mark" in education, and for that I am very proud to be both her colleague and friend.

Eleanor Blair Hilty
Western Carolina University
Cullowhee, NC

ACKNOWLEDGMENTS

The first people I want to acknowledge are my Teacher Education students, both at Queens College and more recently at Borough of Manhattan Community College. Their questioning of the world through the works of art we discussed in our class sessions was my constant inspiration as I developed *Critical Aesthetic Pedagogy*. I am forever blessed for having the opportunity to learn from such an amazing group of people. I want to thank them all for so graciously allowing me to use their voices in this book, and I am especially grateful to my BMCC EDU 202 Fall 2011 classes for their wonderful support.

I want to give special thanks to my personal editor, Lucy Boling, whose support was an invaluable asset to the development of this project; she offered many substantive contributions and transformed my thoughts into lovely language. I also wish to thank Chris Myers and all the staff at Peter Lang for their patience as I worked through the publication process.

Many thanks to Eleanor Hilty and Svi Shapiro, two amazing mentors and educators who helped me find my voice and affirmed my radical views on education as legitimate and worth fighting for. Thanks to the Lincoln Center Institute's Aesthetic Education Program for their teachings, which helped to inspire my educational approach.

Last but not least, sections of chapters two and four were previously published in Penn GSE *Perspectives in Urban Education* Volume 6, Issue 2. Permission to print is gratefully acknowledged.

INTRODUCTION

Like many people in my profession, I did not always intend to become a teacher and a teacher educator—I came to it by steps, through many gradual and precipitous changes and choices of the kind that make up most people's lives. Along the way, I gathered experiences and knowledge that have made me who I am, and have made me good at what I do. What I do is teach; I pour all my passion for life and learning into my classes, and my students give me back as much and more in their turn.

My experiences in a wide range of educational settings have taught me a great deal, and over the course of my career I have formed my own concept of how teaching should transpire, inside and outside of the academic classroom. This book describes the development of an educational model that combines the best aspects of methods I have experienced as a student at the various stages of my education, and experimented with as a teacher finding my way in a changing classroom landscape.

Having established my philosophical base in the theory of critical pedagogy, with its emphasis on acceptance of individual students' voices and respect for the narratives of their lives, I came to feel that something was missing from the theoretical models I had eagerly studied and applied as a student and teacher of educational methods. My discovery of that missing piece, and of my own true power as a teacher and as a human being, is the subject of the narrative that follows.

In Chapter One I will share some elements of my own life story and describe how they have molded me into a teacher, a teacher educator, and a passionate seeker of pedagogies that promote social justice. I will show how my life's path and the choices I have made define who I am today, and explain why I have taken on the battles that I fight with so much fervor. This chapter will provide a personal background for the theoretical discussion I will offer in the next.

In Chapter Two I will present a theoretical framework for my teaching method, describing the fusion of a pedagogical and a philosophical approach: critical pedagogy and aesthetics. This new model promotes the infusion of a particular type of aesthetic experience into critical educational practices in order to help students connect the abstractions they encounter and engage with in class to the realities of the world of their experience. This process enables them to understand and embrace their own power as agents of social change. I call it Critical Aesthetic Pedagogy.

Chapter Three will explore Critical Aesthetic Pedagogy as it functions in a classroom setting. First I will describe my participation in the Lincoln Center Institute's *Aesthetic Education Program* and the insights I gained through that experience, which influenced my development of Critical Aesthetic Pedagogy as an alternative teaching modality. I will then present two case studies based on Critical Aesthetic Pedagogy sessions I deployed in two undergraduate Foundations of Education courses offered at widely differing colleges in the City University of New York system. Although the student populations vary greatly among these schools, the results of my research show that critical aesthetic methods can succeed regardless of students' backgrounds.

In Chapter Four I will describe the most important elements of Critical Aesthetic Pedagogy and discuss how they contribute to the success of my method. I will summarize the range of student responses and address the limitations of the critical aesthetic approach. I will then consider the implications that this approach presents for traditional forms of schooling, and the challenges it will encounter in the current educational environment. Finally, I will review the state of arts education programs at the national and local levels and propose reforms that would allow Critical Aesthetic Pedagogy to take root and thrive in our school systems.

I am honored to share the narrative of my journey, which has taught me so much about the human quest for knowledge, and our common need for profound connection to shared experience and emotion. I hope that readers will recognize something of themselves in my story and will share my dream of offering a truly

transformative education to every student entrusted to our care. This book is for everyone in my profession who believes we can change things for the better, and who is seeking active ways to do just that.

CHAPTER ONE

The Issue of Identity

In order to discover and describe the core of my educational philosophy, I have been reflecting on my personal history, examining it as if I were watching an old home movie of my life, searching through the memories and experiences that I believe shaped my identity. This journey has been painful, therapeutic, and life affirming. It was painful because revisiting my past revived memories of learning and maturing through sorrows; therapeutic because it helped me develop a sense of closure, empathy, and forgiveness; and life affirming because by analyzing my past, I came to understand my reasons for being and my life choices, and I began to envision my future.

This personal search has been complicated, because identity is like a false mirror. As soon as you think you understand and accept it as a definition of your self, it begins to shift and mutate, and before you know it, you turn into someone else. An individual's identity is created from a number of elements that can include but are not limited to race, culture, language, gender, social class, religion, and abilities. These elements engender connections that Amin Maalouf (2000) refers to as "allegiances" (2), and these allegiances can change over time, as we move in and out of the various groups that define our lives as social beings. It is never easy to trace the influences that have helped to shape us as individuals, but the search becomes even more challenging when our lives have crossed multiple cultural and geographical borders.

As I tried to understand the construction of my identity, I realized that it is rife with paradoxes and tugs-of-war that have prevented me from compartmentalizing long enough to define who I am. I am a Dominican and a New Yorker; a rebel and a hyper-

achiever; a Latina with a Southern past; a bad student but a caring teacher; a dancer and a teacher educator; a Salsera and a feminist. These characteristics are often contradictory, yet none of them could have developed without the influence of the others. I am a mixture of all of them, though at times I choose to express more of one than of the others.

Thinking about the development of my identity reminds me of the movie *How to Make an American Quilt,* which tells the story of a group of women creating a marriage quilt for the granddaughter of one of their members. The movie combines flashbacks of each woman's story, connecting their narratives to the individual quilt section each one is creating. As the movie unfolds, we learn how each woman's life has been affected by another member of the group. At the end, when all the stories are sewn together, they compose a quilt of personal connections.

My identity can be seen as a quilt with a narrative sequence, each patch representing a flashback onto a story from my life or an allegiance to one group or another. All these patches of experience are held together by a common theme, like a gold thread running through the quilt in its entirety. This thread represents what I have come to understand as my perpetual feeling of displacement and need to prove my worth.

I cannot remember a time in my life when I felt a sense of completely belonging. I have always felt that for one reason or another I do not fit into the mold created by my surroundings. Throughout my life, I have compensated for these feelings of maladjustment in one of two ways: either by rebelling against authority and refusing to comply with expectations, or by hyper-achieving and striving to become the best at everything, in order to prove wrong all those who seem to lack faith in my moral and intellectual capacities.

In the following pages I will relate the stories connected with some of the patches in my identity quilt, some briefly and others in more detail. Some of these stories will overlap, and some will be contradictory, but they are all pieces of the complex self that I have become. The story of my development as a person, my

discovery and definition of who I am, and my delineation of the paths I have chosen to follow is inseparable from my philosophy of education; I could not have become the teacher I am had I not made the journey I will now describe.

My Life in Two Countries

Born in Queens, New York, I am the only child of two teenagers who divorced before I could form memories of them as a couple. After the divorce, my mother and I moved to the Dominican Republic, her country of origin. The explanation she gave for this decision was that in the Dominican Republic she could provide better educational opportunities for both of us, a better upbringing for me than the one I was receiving in New York City, and a lifestyle she had never enjoyed and would be unable to afford to give me if we stayed. It was during those early years that I first began to feel different from my classmates, relatives, and friends.

The Dominican Republic is a country of extreme social and racial stratification with a strict social structure that resembles a caste system. A very small upper-class group controls the wealth of the country, and the members of this elite have Spanish surnames and light skins, which entitles them to better jobs, greater respect, and more opportunities for advancement. In contrast, the members of the under-class majority have darker skin and a closer genetic link to our shared African heritage. Membership in the latter group condemns an individual to second-class citizenship, inferior education, if any, and few opportunities for financial growth. Most members of this subordinate group serve the members of the elite.

I did not belong to either of these social groups. I was not part of the upper class, because although I attended their schools, my last name did not connote personal wealth. I was not part of the subordinate group, because although I lived with and befriended children in poorer neighborhoods, I attended an upper-class school. Furthermore, I was not interested in the games the children in my neighborhood played, the music they listened to, or the places they frequented. I preferred the activities that the children at my school

took pleasure in and the places they frequented, but I could not afford them financially.

Later in life I began to understand that belonging to a higher social class meant not only having money or a particular kind of surname, but also embracing a system of values, interests, and behaviors that I unconsciously absorbed throughout my school years. I had assimilated the ideals of a privileged class even though I was constantly reminded that I did not fulfill all the requirements for membership. At the same time and for the same reason, I was considered a *comparona* (a stuck-up person) by the children of the other, much larger social group. No matter where I was or who I was with, I was always aware of my otherness.

Years after my mother and I moved to the Dominican Republic, I still found excuses to return to New York City. For months on end I stayed with relatives we had left behind, until my life story was split in two, with half in each country. However, while I frequently traveled to both of these places throughout my teenage years, I always felt homesick for one when I lived in the other, and guilty for leaving loved ones behind. I became what Villaverde (2008) calls a "border dweller," a term she borrows from Anzaldua and defines as "a person who straddles or lives across two or more borders (literal, theoretical, social, cultural, geographic, etc.)" (p. 11). Consequently, I grew up with one foot in New York City and the other in the Dominican Republic, emotionally torn between two countries, two languages, and two cultures.

In addition to my constant homesickness and guilt, there was another reason for my lingering sense of alienation. I was always seen as a *Dominicanita* in New York City, and thus perceived as a naïve little girl who needed to be protected, while in the Dominican Republic I was called a *gringita*, or "little American girl." The latter was more painful to me because Dominicans hold a stereotyped view of American children as a decadent influence on their culture, since the children of American transplants are notorious for using drugs, indulging in sex, and answering back to elders. This stereotype was used to warn those around me, including my mother, that my trips to the United Stated would

make me too *americanizada*. Because their cultural stereotype held that American children were loud and *malcriados*, or disrespectful, Dominicans thought that I needed to be controlled. I spent most of my teenage years trying to prove to my relatives, teachers, and peers in both countries that I was as trustworthy, normal, and intelligent as my cousins and classmates.

A dancer with scars

During all those years of displacement, no matter what country I was in, there was always one thing that remained constant in my life—I was always enrolled in some kind of dance class. There, no one cared what I had done before I arrived, or how I arrived—by plane, car, or foot. No one asked if I was Dominican or *gringa*. No one cared about my last name, just my first. All that mattered was that I wanted to dance, and because of that, I was welcome.

I now understand why to this day dancing remains such a significant part of my life. The dance floor was my first encounter with social justice. It was the only place that offered me an equal opportunity to succeed—a place where achieving success was not connected to my social class or nationality, and where my heritage did not matter. All that truly mattered in this community was my love for dancing. For this reason, ballet, jazz, modern, and Latin dances were at the center of my life as I pivoted precariously across lines of social class, culture, and language.

Consequently, I grew up dancing, and never doubting that I was going to dance for the rest of my life. After graduating high school, I joined a dance group in the Dominican Republic, which greatly reduced the frequency of my trips to New York City. Dancing thus became my whole life. Then, at the peak of my dancing career, I stumbled into a sliding-glass door that shattered, slit three tendons in my left leg, and caused cuts requiring over 1,800 stitches. I was left with little hope of ever dancing again.

Scarred for life, not only physically but also emotionally, I realized that I had reached a turning point and would have to decide where to go and what to do next. My friends and family did not know what advice to give me because they wondered, what

could a dancer do but dance? Perhaps they believed that since I had spent so much time on point shoes, my brain had atrophied.

My old feelings of displacement and need to prove my worth returned in full force: I had lost the only place where they could not haunt me, the dance floor. This time, in order to prove everybody wrong, I promised myself that I would completely forget about dancing. I enrolled in college and became an elementary school teacher. This was a pathway I had never envisioned for myself, and I naturally experienced a sense of mourning for the losses I had suffered. However, my reentry into the world of the classroom set my life on a new path that would eventually bring healing, joy, and a deep sense of fulfillment. Although I did not understand this at the time, I was beginning a journey of discovery that would give me new ways of understanding my place in the world and the contributions I could offer.

"Sunk in the everydayness of life"

A few years after my life-changing accident, I had become a different person. I was living a so-called "normal life"—I had earned a bachelor's degree, I had stable employment teaching at an elementary school, and I had even married. Yet in spite of it all, I was still unhappy.

Looking back on that time, I see that I was what Maxine Greene (1995) refers to as "sunk in the everydayness of life" (p. 14). I felt trapped in what I considered a mediocre life, with no escape in sight. I had lost the capacity to question my life, evaluate its flaws, and consider how to rebuild it. I had forgotten that I had the right and the power to change my world. Before the accident, though feelings of displacement had always haunted me, I still knew with all the strength of my body exactly what I wanted from life, and that conviction had kept me going even when my only goal was to prove my worth. After I stopped dancing, I lost that strength and stopped all my questionings. As a result, I had begun to comply with the expectations of my surroundings regarding social behavior.

After I had been married for several years, teaching primary grades at a private school and living a "normal life," the owner of the school where I worked suggested that I continue my own education. He recommended that I enroll in a master's degree program in Elementary Education at Western Carolina University, where he knew people who could facilitate my entry into the program. I remember that during this conversation I began to imagine a different life for myself, and to believe that I had the power to make that change. I did not hesitate to take advantage of this opportunity, and in a matter of three months, I had moved to North Carolina to continue my formal education.

Today I understand that this choice was, in part, a cowardly escape from a loveless marriage that I knew was bound to fail, and from a life that I had unconsciously rejected. However, at the time I could only see (and admit) as much as my pain would allow. I also knew that my new choices would bring as much pain to my loved ones as the happiness they had felt for me before, unaware as they were that I was secretly miserable. Launching myself into the unknown, I left my home, my marriage, my friends, and my mother to move to the United States to pursue a master's degree in Elementary Education, and subsequently a Ph.D. in Educational Leadership and Cultural Foundations at the University of North Carolina at Greensboro.

My feelings about leaving home were again very complex. I wanted to avoid being "sunk in the everydayness of life," and I felt excited about starting a new life full of possibilities. Yet at the same time, I felt guilty for abandoning my home, my memories, and those whom I loved. My new and unfamiliar surroundings filled me with apprehension, and I was unsure of my ability to speak and write in English at the graduate level. Most of all I was insecure about fitting into the strange Southern culture, something I so desperately needed to do in order to succeed.

Who am I?

Life in the South was very different from life in the Dominican Republic, and based on what I remembered, from life in New York

City. On the one hand, I was the only Latina in both of my graduate programs. On the other hand, the racial issues that take precedence in the South regard Black and White. For this reason, I felt very uncomfortable participating in class discussions about race and ethnicity. Although Latinos and African Americans share a history of slavery and oppression, race is a social construct, and therefore a lived experience. I was not African American and I was not White. I felt like a plantain in a basket of fruits.

Furthermore, this feeling of social discomfort inhibited my ability to communicate in English. Sometimes after gathering the courage to participate and stating my opinion about an issue raised in class, I would immediately realize that my comment had not come out the way I had intended. Nevertheless, my statement would initiate a discussion among my classmates, and by the time I could mentally organize what I had really meant to say, the moment was gone and the class had moved on to something else, leaving me with a sour taste of stupidity and inadequacy. Maalouf describes the total alienation I experienced during this period:

> The secret dream of most immigrants is to try to pass unnoticed. Their first temptation is to imitate their host, and sometimes they succeed in doing so. But more often they fail. They haven't got the right accent, the right shade of skin, the right first name, the right family name or the proper papers, so they are soon found out. (Maalouf, 2000, p. 39)

My biggest fear was indeed of being "found out." I was terrified that my professors would eventually realize that I did not belong in the program because of my limited intellectual capacity, insufficient English proficiency, and horrible writing skills, or just because I was a woman who had somehow squeezed into the program through the back door.

To preserve my sanity, confront my feelings of inadequacy, and find a way to feel comfortable when speaking about issues of race, I began a search to define my own racial identity. Not being White or Black, what was I? Was I Hispanic? Latina? American? Latin American? Who was I, and what did I stand for?

After months of reflection and reading the work of various Latin American intellectuals on the construction of race, I decided to call myself Latina. I did not choose the term Hispanic, because it is linked to my people's colonizers and oppressors, the Spaniards. I did not choose American, because although I was born in the United States, I was raised primarily by Dominicans in the Dominican Republic, and I felt a strong connection to that country and its culture.

I must point out that I use the word Latina with caution, because I understand that the term Latina/o can also function as a reductionist social construct that places all people from Spanish-speaking countries into one category, thus perpetuating the belief that we all belong to a single culture and therefore must all act the same way. In addition, this term is problematic because it is used only in the United States. People from the Spanish-speaking countries of Latin America do not think of themselves as Latinos; they define their identity according to the specific country of their origin.

Nevertheless, I believe that in the past few decades, the rush of immigration into the cities of the United States by so many Spanish speakers of different nationalities, including Cubans, Puerto Ricans, Dominicans, Colombians, and Mexicans, has engendered interracial relations with both Whites and Blacks that have allowed for the development of a common political discourse. This discourse has produced a cultural category that I will refer to as Latin American. It has also defined my choice of racial identity: I am Latina.

Awakening in my body

I must admit that the years in graduate school were intellectually challenging. I spent that time searching for a place of belonging, reading books that stretched the boundaries of my understanding, and participating in extraordinary class discussions. However, I also spent those years in denial. The intellectual demands of graduate school could not keep me from thinking about the void I felt in my body and soul because I was not dancing. I wanted to

show everyone that I had a brain and that I knew how to use it, and to prove this point, I had even been willing to leave my loved ones behind. By the time I graduated with my master's degree, I realized that I had everybody fooled: they all thought the dancer in me was completely gone. I had convinced them that I was nothing but an oversized brain walking around with no body attached to it—and that is exactly how I felt. I enjoyed my new intellectual identity, but it was hard to keep from thinking about dancing, even though those thoughts were so painful for me.

In order to make sense of new information, people process it first by relating it to previous experiences. In my case, because I had decided to concentrate on my intellectual development and reject the memories of my life as a dancer, I had to create a new way of understanding that was completely disassociated from my earlier experiences. I was practicing what Paulo Freire (2000) has called the "banking concept of education" (p. 72), in which the learning process is disconnected from the student's life. I was bottling in the new knowledge to separate it from my lost life as a dancer, and when I found a way to do that successfully, I was in good shape...*or so I thought.*

It was during my doctoral work at the University of North Carolina at Greensboro that I first learned about the notion of the body-mind split. This idea haunted me for a long time, because although it resonated with my experience, I still could not draw a direct connection with what I was going through at the time. Then one day I met a man named Oren, who became my friend and later my dance partner. He invited me to go Salsa dancing, and I will never forget that night. As I danced, I awakened in my body for the first time in years.

Suddenly I understood the real meaning of the body-mind split. This concept holds that in our society the mind is more important than the body, thoughts are more important than feelings, and reason takes precedence over emotions, in an ideology that separates thinking from being and devalues experience as a creator of meaning. The alternative view is what Sherry Shapiro (1999) refers to as *body knowledge*: "both mind and body mingle

together in a continuous informational stream creating the interpretations we call knowledge. As such, we experience our interpretations as reality" (p. 33).

I was a living example of this concept of body-mind separation. My mind was divorced from my body, not because I had given up dancing, but because I had thrown away the most valuable tool I had for creating meaning and understanding the world. I cannot understand how I could have gone for so long without that vital connection to my body, which had previously channeled all my expressions of love, joy, passion, and compassion. When I look back at that time in my life, those disembodied memories appear in black and white—blurry, odorless, and tasteless. When I began to dance again, the emptiness I had felt for so long, and had tried so hard to ignore, simply disappeared. Since then, I have continued dancing as an essential part of my integrated identity.

Latina Salsera

At that point, my allegiances shifted once again, and I became a *Latina Salsera*, an allegiance that I still carry with pride. Consequently, during my last few semesters in graduate school and after a hiatus of many years, I again began traveling to New York City, the capital of Salsa, for training and exposure.

Little did I expect that in New York I would discover a new community among the *Salseros Dominican-Yorks*, or Dominicans living in New York. Finally, I found a place where I belonged, full of people who saw the world and created meaning in the same way I did: *through our bodies and our culture*. Kathleen Casey (1995) calls this kind of discovery "a Collective Subjective, [where] in the process of articulating a common political discourse, individual isolation is overcome, and identity is created in community" (p. 223). Needless to say, as soon as I finished my Ph.D., I moved back to New York City.

However, to my dismay, it did not take long before I began to feel displaced in my new surroundings once again. Now the feminist in me was screaming accusations that I was perpetuating machismo and traditional sexism by conforming to the demands of

a dance style that is sold as a "lead-and-follow" dance, in which men are the leaders and women follow.

One way in which Salsa instructors typically sell their lessons to the public is by claiming that in this age of women's liberation, Salsa dancing is one of the few arenas where men are still in charge. I often heard a particular instructor say during a lesson, "Women, you may be the bosses everywhere else now, but here, men are still in charge." The men would often cheer and applaud this kind of statement. These comments were disturbing to me as a feminist, because although I love Salsa, I felt that by allowing a man to lead me I was giving in to traditional sexism.

This internal dissonance motivated me to attend classes at different studios to compare how other Salsa instructors taught the "follow-and-lead" techniques. I hoped to find a way of easing the tension between the feminist angel (in cap and gown) who stood firmly on my right shoulder, hitting me over the head with my Ph.D. diploma and insisting that I was perpetuating female oppression, and the *Salsera* angel (in a red, glittery outfit) on my left shoulder, shaking her hair and moving her hips to the sound of the congas.

Finally, I found a Salsa school called Santo Rico Dance, Inc., where I would learn how to resolve this conflict. The owner, Tomas Guerrero, was also a teacher with a more acceptable philosophy: "to lead and follow is to know the right moment to react to the actions of your partner." With his help, I came to understand that leading and following are both learned behaviors and equally important skills. Following is not a natural capacity that women are born with, any more than cooking is. Both men and women have to learn and master all the skills necessary to create a well-balanced partnership. Dancing is about two partners giving each other just the right amount of body tension so that when one initiates a move, the other translates it into a shift of weight that will complete the paired movement. If either partner does not give the right amount of tension back to the other, they both fail to create the dance move. In other words, to lead and to follow means knowing the precise moment in which to "act" and "react." Thus,

despite the macho sales pitch I had heard so often in other dance schools, I concluded that Salsa dancing is based on mutuality, partnership, communication, and the sharing of equal strengths at precise moments. *Imagine my relief!*

Why did I become a teacher?

Based on the early memories I have described so far, it may be difficult to understand my choice of teaching as a profession. I have analyzed my negative feelings of displacement and intellectual inadequacy, and my positive experiences of reawakening to the truth of my body and finding a *collective subjective* among the Salseros Dominican-Yorks. However, none of this explains why I became a passionately committed teacher and later a teacher educator. Perhaps after my life-changing accident, I was subconsciously motivated to choose teaching as a career, as a way of helping others. Yet I needed to search deeper into my life to discover my true motivations.

Another journey through my memories took me back to my middle- and high-school years in the Dominican Republic. This was a difficult and problematic passage, because I have very little recollection of that time. At first, all I could remember was the sheer boredom of sitting for hours on end in rooms where teachers "blah blah blahed" their way to the end of the period. I remembered taking notes and memorizing a lot of information, not because it had any relevance or appeal for me, but because I knew that later I would have to spill it out on a test. I also remembered skipping many classes. Then I began to recall punishments and complaints made against me, and I felt a renewed hostility toward some of my old teachers. I could not think of a single reason why I should have wanted to become a teacher. I had detested school!

Then I thought that perhaps those hateful memories of school were precisely what drove me to become an educator and made me so passionate about education and social justice. I did not have a wonderful schooling experience, and my teachers did not serve as positive role models. In fact, my few recollections of school are oppressive, painful, and silencing. Worst of all are the memories of

those moments in which I acquired the reputation of a *malcriada*—a disrespectful girl—because I could not keep my mouth shut and spoke up whenever I felt injustices had been committed toward my peers or me. This reputation in turn made me rebel even more. "Unquestioned authority" was not in my vocabulary. Nevertheless, with time, the punishments and complaints had served to silence me and fueled my feelings of inadequacy and my compulsion to prove my normalcy.

The truth is that I became a teacher despite these horrible experiences, but also because of them. Intuitively, I knew that there were other ways of approaching students, and I needed to discover them. I wanted to see children as more than "deficit pieces, [for when they are] unable to be affirmed for the strength they possess, children come to know themselves only in the places where they need extra help, whether those places mean academics, social skill or their bodies" (Pennell, 2010, p. 41). Perhaps I wanted to do my best, first as an elementary school teacher and later as a teacher educator, so that the children whose lives I touched—directly and indirectly—would have a different schooling experience than I had endured.

As I searched for alternative pedagogies that empower students to become embodied learners and teaching methods that do not perpetuate pain, disconnection, and oppression, I attended numerous graduate courses and education conferences with professors and speakers known to promote alternative classroom environments. Most of these encounters were wonderful. The professors and speakers helped me shape and understand my world, affirmed my radical views as legitimate, and—most importantly—helped me to determine the type of classroom I wanted to create, by modeling mostly positive and some negative pedagogical examples.

A story with three lessons

In one particular graduate course, I was very disappointed with a White male professor who claimed to follow a liberating feminist pedagogy when in fact his course mirrored a conservative,

patriarchic, and silencing educational model. This class was composed mostly of women, with one White male student. Throughout the course, the professor and the male student managed to monopolize the discussion to the point of silencing the rest of the class. Worst of all, this environment of patriarchal camaraderie blinded the professor to the fact that on the few occasions when female students managed to participate, we were always interrupted by the male student with corrections of our words, based on what he believed we meant to say.

After a few months of bearing with this situation, I found myself repeatedly interrupted one day in the middle of an oral presentation, and I could not restrain myself from walking out of the class, never intending to return. My advisor subsequently arranged a meeting for me with this professor so that we could discuss this situation. I was horrified by the prospect of confronting him and speaking up for myself, after years of being socialized to believe that doing so was a sign of disrespect. I felt as if I was back in grade school; once more I was little Jolie Medina, "*la malcriada.*"

To prevent my emotions from getting the better of me in this meeting, I wrote down what I wanted to say and went to meet my nemesis. Then, in a flood of tears, I expressed my extreme discomfort with his class and explained how oppressive it was for me and for the other female students. He listened to everything that I had to say, handing me tissues to dry my tears. Then he proceeded to inform me that although he was saddened at this situation, he felt that his class was not a therapy session, and that it was not his job to pamper students. He also said that it was our responsibility as graduate students to fight for the right to speak when we wanted to participate. After that day, I never returned to his class, nor did I speak to him again. There would be no point in it, as we viewed education through very different frameworks that would always prevent us from seeing eye-to-eye.

I include this anecdote because, as a spiritual person, I believe that everything happens for a reason, and that no matter how painful an experience may be, I should learn from it and turn it

into a life lesson. In this spirit, I would like to describe the three lessons that I learned from my encounter with this professor.

First, I learned that while educators may have the best intentions of promoting a liberating classroom environment, they still can inadvertently perpetuate ideologies of oppression. Although this professor called himself a liberationist pedagogue and a feminist thinker, he failed to see that his method of conducting class was based on masculine ideals of independence, detachment, and competition, as opposed to connection, care, and compassion, which are the primary characteristics of a liberating feminist pedagogy. Second, although I do not propose that classrooms should become group therapy sessions, I do believe that education should be healing, rewarding, and constantly respectful of human dignity. Finally, this experience made me realize how important it is to ensure that every student's voice is acknowledged in the classroom. This can only happen if we, as the facilitators of discussion, become actively involved in providing each student with the opportunity to speak, even if this means limiting the participation of the most vocal individuals in the group.

Santo Rico Kids Cultural Center

The Santo Rico Kids Program is my life and soul...
It is my legacy.
Once upon a time I wished I could teach children,
I wished I could teach dance,
I wished I could honor my culture by creating a space for others to rejoice with me,
I wished I could gather families together,
I wished to live surrounded by friends,
I wished I could bring together a sense of what it means to be a New Yorker, a Latina, and an American, and not feel confused about it.
The Santo Rico Kids Cultural Center made my wishes come true.
For that I live in blessings.

Yolanda Medina, Founder

I had been living in New York City and dancing Salsa at Santo Rico Dance, Inc., for several years when Tomas Guerrero, the school's owner and dance instructor who had helped me to incorporate the true spirit of Salsa into my feminist worldview, suggested that I start a children's dance program at the school. Honored and enthused about the possibilities this project offered, I launched into the creation of the Santo Rico Kids Cultural Center.

This fulfilling work connected with so many of my allegiances: the educator, the dancer, the Salsera, and the Dominican-York. Thinking back at the time, I realized that I had taught children and I had danced, but I had never taught children how to dance. This project also offered me the opportunity to create an environment for children and their parents that promoted the democratic values of inclusion, acceptance, equality, and diversity—values that I had searched for as a student and tried to promote as an educator. In other words, creating this program provided me with an opportunity to offer others the safe haven that the dance floor had given me as a child—a place to feel welcome regardless of heritage.

Thus the Santo Rico Kids Cultural Center was born, first offering classes in Salsa, and later including other genres such as Hip-Hop, Afro-Cuban, and Jazz. The program's mission statement articulated all of my educational ideals:

> The Santo Rico Kids Cultural Center is dedicated to providing outstanding multicultural awareness and acceptance to children ages 4–18 through the study and performance of the arts in a democratic, non-competitive, and non-discriminatory environment. Santo Rico Kids Cultural Center intends to offer all types of arts representing the population it serves as a way to support parents of the community in the teaching of cultural pride.

Through the study and performance of diverse cultural arts, children will learn to:

- accept difference

- recognize the importance of multiple perspectives in a democratic society
- work in collaboration
- understand the importance of community
- interact with other children and adults in a non-competitive environment
- take pride in their own culture

By the third year of its operation, the Santo Rico Kids Cultural Center was blooming into one of the most respected children's Salsa schools in the city. Located in Spanish Harlem, the program enrolled over 100 students of diverse social classes, cultures, and languages. It sponsored two professional children's dance teams: The Santo Rico Kids, consisting of boys and girls, and the Santoriquitas (Little Santo Rico girls), an all-girls team. These groups frequently traveled to perform in world-renowned events such as the Orlando Children's Salsa Conference, the New York Salsa Congress, and the Puerto Rican Day Parade. The children attended summer dance camps on full scholarships and were interviewed by Telemundo, a Spanish-speaking television channel.

The school offered various levels of dance instruction in multi-age settings. Every June, we gave a recital in a public theater, and all the children's family members and friends, and even their schoolteachers, gathered together, filling the hall to capacity to see the children show what they had learned that year. There were new choreographies, costumes, makeup, and glitter—lots of glitter and laughter.

Best of all, the Santo Rico Kids Cultural Center was a family. The children, instructors, and parents organized every trip, party, and meeting, and these events were always fully attended. Parental involvement always exceeded my expectations, and dance classes were filled with chatter and joy—instructors teaching, children dancing, and parents laughing and enjoying each other's company.

One memory that I hold especially dear was the birthday party we held for Julie, the youngest of the founding students. Her

mother had to travel abroad to attend a relative's funeral, and before leaving, she asked if it would be possible for us to celebrate Julie's seventh birthday at the studio. The day of the party, the studio was full of students, parents, and instructors, all gathered to support and celebrate Julie's birthday. When her mother returned, she presented us with a framed composition Julie had written describing her birthday party and her joy at sharing this happy day with our extended "family." To this day, that memento remains in my office as a reminder that simple expressions of care can seed children's memories and influence them deeply in positive ways.

Of course, not everything at the studio was smiles and hugs; there were occasional conflicts, as can be expected in any truly democratic environment. Some of these were resolved immediately, some took a little longer, and others simply faded in the course of time as the point became irrelevant. In any case, whenever families walked into the dance studio they always felt welcomed, and everyone eagerly looked forward to dance classes, parents and children alike.

Ten years have passed since the inception of the Santo Rico Kids Cultural Center, and the program continues to offer a safe haven for children in Spanish Harlem and vicinity. The founding students have outgrown the program, and most have moved on to college, some with full scholarships, while others are still completing high school. Some of these children continue to dance Salsa, and Julie is dancing for Tomas Guerrero in the Santo Rico Dance Company at the age of 15. Other children have found different forms of expression such as cheerleading, break dancing, Hip-Hop, sports, and playing various musical instruments.

Most importantly, all of them have successfully continued their education and have developed leadership skills that will help them to be successful members of their communities. I feel a humble gratitude for the gifts the program has given me, and I am proud to think that I may have contributed something to the students' successes.

The importance of imagination

During the period when I was founding and running the Santo Rico Kids Cultural Center, I also held a two-year position as an Instructor in Elementary and Early Childhood Education at Queens College, where I taught Social Foundations of Education at both graduate and undergraduate levels. Today I am an Assistant Professor in the Teacher Education Department at the Borough of Manhattan Community College of The City University of New York. I teach Social Foundations of Education and coordinate the Childhood and Bilingual Childhood Education programs. The majority of my students are Black or Latina women of limited means.

These community college students, like me, are mostly non-traditional students. They return to school after experiencing life for a number of years, and/or they belong to marginalized groups based on their race, gender, and/or social class. They often report having to juggle their lives in various worlds. In the context of the college environment, their struggle is to become members of an academic community while trying to retain their identities as members of their own local communities; like me, they are "*border dwellers.*" For this reason, my students come into the classroom with a rich background of experiences that can easily be connected to the issues of oppression and privilege discussed in Teacher Education courses that are geared toward addressing social justice concerns.

I believe that my students share my views about how issues of discrimination and privilege affect children and their schools. Yet I still hear a tone of despair in their voices, and very little if any hope for a better future. They are doubtful of their authority and power to change the current systems of domination. As future educators, they want to become healers of children's suffering, but it seems as if a huge wall stands before their eyes, and they cannot see any better alternative. They cannot imagine a life that differs from their experience.

Hearing my students express the same desire and mental blockage semester after semester made me realize that in

developing my educational model, which was based on the inclusionary principles of critical pedagogy, I had neglected an important factor that I now consider indispensable for the empowerment of students to create social change. I had failed to take into account the influences of my students' previous learning experiences, which, like my own, had been limited to "the banking concept of education" as Freire (2000) described it. In this approach, students' individual ways of interpreting the world are not valued. The learning process is disconnected from their lives, so they can never truly embody the knowledge they receive, or understand that they can use it to transform the world. Furthermore, because this approach to learning is one-dimensional and hierarchical, it leaves little room for critical and independent thinking. Even worse, it reduces one's capacity to imagine. Thus, students come to see the world as fixed and given.

This was the flaw in my teaching model: my students' underdeveloped powers of imagination limited their ability to actualize the knowledge they gained through participation in my courses. They were coming to my classroom, sharing their experiences, and linking them to issues of oppression and the need for change, but they still could not imagine a better future and therefore did not believe in their own power to create and recreate their world.

After coming to this realization, I began to think about my own life story and compare it to those of my students. Correlating our lives and experiences, I found that I shared five or six characteristics with many of them: they were mostly women, non-traditional students, and people of color who grew up poor, spoke English as a second language, and were either immigrants or children of immigrants. However, there was one basic yet crucial difference between us: my students lacked the capacity to "see things as if they could be otherwise." Recalling that my own sense of identity and personal power was rooted in my experiences as a dancer and a participant in artistic encounters, I came to believe that this was the missing piece in my educational model. I believe that my involvement with the arts has allowed me to imagine

possibilities that my students cannot (yet) envision, and that exposure to artistic expressions of suffering, longing, redemption, peace, and renewal can help them connect with their own power to change the world they have inherited, and will lead.

This journey has helped me define the kind of pedagogy that I am committed to creating, which has two key characteristics. First, it must promote models of learning that embrace human beings with dignity and respect; this must be a pedagogy in which students' interests and experiences become the most important tools in the classroom, and knowledge is shaped using their own ways of understanding the world. Second, these educational models must feature encounters with the arts that will help students develop their capacity to imagine an end to unnecessary suffering, and to create much-needed social change.

My mission as a teacher educator is to model this new pedagogy to future teachers, so they in turn can model it to their future students. To rephrase a quotation from Tupac Shakur in the film *Resurrection* (Lazin, 2003), I may not be the one who changes the world, but I want to spark the minds of those who will.

CHAPTER TWO

Critical Aesthetic Pedagogy

It may be the recovery of imagination that lessens the social paralysis we see around us and restores the sense that something can be done in the name of what is decent and humane. (Maxine Greene 1995, p. 35)

I have described the personal journey that carried me through my years as a young Latina straddling two worlds, a dancer finding acceptance in a community that embodied social justice, and a beginning teacher looking for new ways to incorporate egalitarian and progressive methods into working classrooms. I have shared how my feelings of oppression as a student shaped my decision to become a teacher, a teacher educator, and a passionate seeker of pedagogies that embrace personal experience as a backdrop for creating meaning, understanding one's past, and determining one's future. Now I will detail my intellectual journey as a student and an educator and explore the philosophies that have shaped my vision for a new pedagogical approach.

Throughout my graduate education, I studied the paths taken by pedagogues who promote alternative methods of teaching, encourage the expression of students' voices in the classroom, and value experiential knowledge. My studies provided valuable insights into the social and psychological factors that determine how teaching methods work in real classrooms. However, my own experiences as a student and a teacher led me to believe that the results I was seeking could only be achieved through a fusion and expansion of the teaching methods I had learned.

This chapter will present a theoretical framework for my new pedagogical theory, based on the work of renowned radical educators such as Peter McLaren, Maxine Greene, Paulo Freire, bell hooks, Sherry Shapiro, and Susan Stinson. It will describe the fu-

sion of a pedagogical and a philosophical approach: critical pedagogy and aesthetics. My new paradigm promotes the infusion of a particular type of aesthetic experience into critical educational practices in order to help students connect the abstractions they encounter in class to the realities of the world of their experience. This method will allow them to understand and embrace their own power as agents of social change. I call it Critical Aesthetic Pedagogy.

Theoretical Framework

Critical pedagogy provides the foundation of the framework upon which I will base my analysis. This educational theory contains several elements that I consider crucial to Critical Aesthetic Pedagogy. The first of these is the creation of classroom spaces where students feel safe to share their personal experiences, and where these experiences become the most important educational tool. The second element is the challenge to existing forms of schooling that are based on a conservative model in which teachers function as knowledge providers and students passively absorb the information handed down to them. This educational model reinforces dominant systems because it discourages critical and independent thinking and gives teachers absolute power to decide which information is most important. The third crucial element of critical pedagogy lies in encouraging students to explore how their experiences shape their identities and how they are marked by the larger culture in which they live. Students then can be taught to find their own voices by critically analyzing their cultural identity and its influences.

The value of experiential knowledge

The first essential element that I borrow from critical pedagogy is the establishment of a classroom environment in which students feel accepted and safe to share their personal experiences. This requires pedagogical guidelines designed to ensure that the dignity of every person will be preserved, no matter how unusual their opinions might be or

how uncomfortable they may make the other students feel. A critical aesthetic classroom must be a place of interaction and engagement, where students' worldviews and opinions are considered the most valuable resource for learning. This requires that the instructor's agenda remain fluid and open to continuous transformation. Each encounter with students will present a new approach to the subject, depending on the students' experiences and how they interpret them. Instructors cannot walk into the classroom with a set plan for the day; they must leave room for flexibility and change, because each day and each topic discussed will reveal a new set of experiences and interests that may or may not allow progression to the next topic in the agenda.

Critical pedagogy encourages democratic ideals in the classroom because it assures all students the fundamental right to participate and to be heard. The students are free to make decisions about their own learning process by determining when it is time to move on and when to explore a topic of particular interest in greater depth. I see this form of pedagogy as a dance. The teachers and students are like dance partners in constant graceful movement, and the curriculum shifts with every encounter depending on the students' needs, interests, and experiences, and the ways in which they understand the world. Critical Aesthetic Pedagogy borrows this ideal from critical pedagogy and encourages a form of education that is inclusive, holistic, and multicultural in every regard. It embraces the truth that students come into our classrooms bearing different kinds of knowledge, depending on their background. Their experiences shape the ways they see the world, and the ways in which they learn. It is the critical aesthetic educators' responsibility to meet each student's needs by connecting the learning process to the culture in which they have learned how to learn.

A successful Critical Aesthetic Pedagogy must allow students to use their own personal experiences to find a sense of connection with the learning process. The critical aesthetic educator has to ensure that students learn by employing the knowledge they bring into the classroom as the basis for furthering their own education. Engaging with students' experiences must be the primary factor in

this transformative pedagogy, because the practice of connecting their experiences to the learning process allows students to personalize the knowledge they are gaining, and that is how it becomes relevant to their lives.

Critical Aesthetic Pedagogy also emphasizes the importance of teachers bringing their own experiences into the classroom and linking them to the academic discussion. In this way, teachers can be seen as whole human beings who exist outside the classroom walls, with complex lives in which they love, care, and struggle for meaning. Furthermore, when we as teachers share our own stories in the classroom, students can draw a connection between our love for the subject we teach and the discipline itself, and our teaching can thus become a significant force in their lives. If we are going to expect students to share experiences relevant to the learning process, we need to do the same.

Today's dominant educational model suffers from a lack of relevance. Students are often expected to memorize information without connecting it to the realities of their own lives, and this rote learning process discourages them from becoming active and involved participants in their own educational process. Instead they become passive recipients of bits of information that are fed to them by an authority figure, and they are never expected to interpret or make meaning out of the information they receive. An educational system that considers knowledge as fixed and unchangeable leaves no room for students to determine the relevance of what they learn, and it discourages critical analysis. Relevant meaning can only be created when we relate our personal knowledge to the new information we receive. Boyd White (2009) explains this best:

> While each [new experience] compares with others, the result is a kind of layering up of the totality of experiences and divisions into categories of perceptions to which we respond in a manner typical to us as individuals and as members of a particular culture and time. (p. 3)

As critical thinkers, we must learn to analyze new information using our accumulated life experience, drawing on what we have

encountered in the past to determine how we can best utilize our new knowledge in the future.

The challenge to existing forms of schooling

By allowing students to relate their personal experience to the learning process, critical pedagogy challenges existing forms of schooling, and this is the second crucial element I have incorporated into Critical Aesthetic Pedagogy. In my experience as a professor of Social Foundation of Education at both the undergraduate and graduate levels, I have found that most of my students have been shaped by a pedagogical system that is hierarchical and non-interactive. In this system, students are reduced to storing bits of information provided by their instructor, who considers her/himself as a superior authority. The students are objectified and treated like empty vessels to be filled with information learned by rote. Students' experiences and ways of interpreting the world are not valued. The learning process is disconnected from all social relevance, and students are prevented from creating meaning out of what they have learned.

> The more students work on storing the deposits entrusted to them, the less they develop the critical consciousness which would result from their intervention in the world as transformers of that world. (Freire, 2000, p. 73)

Traditional forms of schooling, in which experiential knowledge is not viewed as a legitimate route by which to create meaning, can only perpetuate social inequalities. Each individual's identity is shaped by culture, language, social class, and gender, among other factors, and these can all be seen as different lenses used simultaneously to view the world. All individuals will see the same situation differently, because prior experience serves as the context in which they understand each novelty they encounter. For example, the perspective of a poverty-stricken immigrant Asian woman differs from that of an upper-class White American male, because they have been exposed to vastly different lifestyles, and this affects how they perceive the world. If they meet in the same classroom, these two individuals will create meaning in very different

ways based on the habits they have learned through years of socialization under extremely unequal circumstances.

By assuming that experiential background does not affect classroom learning, traditional forms of schooling can produce infertile knowledge, because they do not allow individuals to interpret new information through the lens of their prior experiences, and thus to create meaning that is relevant to their worldview. Furthermore, by denying that culture, language, social class, and gender are the main influential factors that shape our identities and the ways we create meaning, the traditional model reinforces existing systems of domination, as I will now explain in greater detail.

Culture and language. Peter McLaren (2003) defines culture as "a set of practices, ideologies, and values from which different groups draw to make sense of the world" (p. 200). Culture is experienced and perpetuated in the context of individual lives, and when students are not allowed to use their own cultural experiences as a background for the learning process, the knowledge they gain through study remains irrelevant. Some educators claim that curricula should be "color blind," but I argue that such practices are just as detrimental to the learning process as the "banking" approach. When an instructor decides on a "color blind" classroom, the students' authentic voices are eliminated from the conversation, and the instructor remains the only legitimate source of knowledge.

Culture and language go hand in hand, and one cannot separate the language we speak from the way we understand the world. A classroom that does not respect students' language differences fails to take into account the multiple ways in which students may relate to study materials based on the language they are raised to speak. For example, a student whose native language is Spanish might struggle to answer questions posed by a teacher who is a native speaker of English. Not only is there a language barrier to comprehension, but the thought process reflected in the Spanish language also differs from that of English. Sleeter and col-

leagues (1994) explain:

> The syntax of the Spanish language is broad, open, and free in structure. The English language is restrictive and economic in word usage because the Anglo thought is different from the Hispanic thought. To an Anglo who does not understand this a Hispanic student might appear to talk around a point imprecisely; conversely, to a Hispanic student an Anglo might appear to speak too bluntly and even rudely, and to move through ideas with excessive speed. (p. 151)

This linguistic and cultural incompatibility can create a barrier between students and teachers that makes it impossible for students to feel comfortable sharing their experiences, and this in turn can cause them to withdraw from class participation. A critical aesthetic educator must be aware of each student's background, language, and culture in order to use these factors to best advantage for the benefit each individual's education. Critical Aesthetic Pedagogy must affirm the validity of all students' voices as valuable tools for understanding the world and shaping knowledge.

Social class. Social class is not merely an economic construct; it also shapes the values and attitudes that define the ways in which knowledge is given and received. The values of the dominant social class determine how an individual must behave in order to be considered educated in any given society. In our society, for example, an educated person is always expected to maintain control over her/his emotions and actions. To appear emotional, passionate, and loud is considered the mark of a subordinate, uneducated social group. Although these rules are never overtly stated, they are reinforced by a social system that rewards stoic calm and emotional detachment. This social imperative can create a classroom environment in which it is deemed inappropriate to express one's feelings and beliefs.

When the expression of personal experience is welcomed into the traditional classroom, it is the experience of the dominant class that dominates the discourse. This is what bell hooks (1994) refers

to as the "materially privileged class experience" (p. 181), or that of the middle-bourgeois and upper-class groups. To avoid feeling like outsiders, students from other class backgrounds may choose to remain silent, or to adopt a demeanor that will help them assimilate into the privileged class group. In such cases, students from non-privileged groups will continue to receive irrelevant information, because they cannot use their own life experience to create meaning from the new knowledge they receive. What is worse, some students may feel unable to endure such an environment at all, because the gap between who they are and what is expected of them—in other words, the gap between their home culture and the academic world—seems too wide to bridge. Critical Aesthetic Pedagogy rejects the notion that students from subordinate cultural groups must give up their class values in order to attain an education they can use.

To consider the other side of this equation, students from privileged groups may see loud and passionate discussions as rude and threatening, and thus they may be silenced by the relative tumult of an experiential classroom. The job of the critical aesthetic educator is to help all students find their own safe spaces in a classroom in which they may participate and learn. Such spaces can be created with small group discussions, or through regular journal entries in which students can reflect on class assignments and state their opinions without feeling exposed or expected to assimilate unfamiliar class values. Critical Aesthetic Pedagogy creates a classroom environment in which class differences are used constructively—a space of interaction where students exist primarily as human beings and their differences are accepted, valued, and encouraged.

Gender. We live in a society that is ruled by the ideology of patriarchy, which honors masculine over feminine views and interpretations of the world. Over the centuries, masculine ways of being and thinking have dominated cultural values to the point of practically eliminating the feminine perspective from general discourse, giving men the authority to control the public arena.

This social reality has traditionally silenced the voices and de-valued the experiences of women in our culture. In an article enti-tled "In the Beginning They Are Babies" (2003), Angela Phillips describes how at an early age boys begin a process of emotional separation from their mothers and from all that is perceived to be female, in order to be socialized as males. This ideal of independ-ence and emotional detachment is what psychologists and social theorists have traditionally used as the standard to define the pos-itive characteristics of individuality, autonomy, and maturity. Girls do not typically go through this separation process because they are expected to maintain a constant relationship with their mothers, who are also female. As a result, girls tend to grow up with a greater sense of relationship and social connection, as op-posed to the male ideal of individuation and autonomy. Because a patriarchal society values the masculine over the feminine, inde-pendence and emotional separateness have become central values of our dominant culture, while characteristics that facilitate rela-tionship and connection are seen as belonging to the female world, and are therefore considered subordinate.

Applied to classroom practice, the belief that emotional separateness is more valuable than emotional connection prevents students from sharing their personal experiences as an integral part of their formal education. This means that in order to be educated, female students are expected to abandon the way they traditionally create meaning and understand the world—through relationships and emotional connection. On the other hand, male students are often silenced by an environment that encourages the sharing of experience, because if they choose to share, they may be seen as adopting the demeanor of the weaker group. A truly transformative pedagogy must be based on an educational framework that eliminates such gender hierarchies. A critical aesthetic classroom must become a place where students of both genders feel comfortable sharing their experiences, and thus can use them to learn from one another. Here again, small group discussions and reflective journal entries can help to encourage this type of experiential growth.

Exploring identity in the classroom

There are some who question the validity of using students' personal experience as a tool for self and social empowerment. Postmodernists would deny the value of personal experience as a source of social justice in education, because experience is socially constructed, and therefore ultimately under the control of those in power. However, critical pedagogy is concerned with questioning the relationship between experience and culture, and examining how experience shapes individual identity. This process helps individuals deconstruct the unquestioned hierarchies of power and allows them to critically analyze how these hierarchies have affected their identity. This is the third fundamental element I have incorporated into Critical Aesthetic Pedagogy.

As I described in the previous chapter, an individual's life experiences shape what can be referred to as allegiances, and each allegiance is constructed from a collection of related experiences. For example, positive experiences within one's culture, religion, social class, or gender can create a sense of belonging and pride, which reinforces one's allegiance to the group or subgroup in question. Conversely, negative experiences may cause an individual to reject any of these social groups.

Such allegiances are complex and multilayered and can complement or contradict each other, because characteristics of race, gender, and social class define interrelated groups. In any individual, one allegiance may come to dominate others, thus creating internal hierarchies that define one's identity, but can change over time as new experiences shift the focus of the allegiance. We are constantly abandoning old definitions of our "self" and elaborating new ones, each with its own set of rules and behaviors.

The main aim of Critical Aesthetic Pedagogy in this regard is to help students recognize the existence of their varying allegiances, and how they are influenced and shaped by dominant ideologies in mainstream culture. These allegiances are then analyzed to reveal an assortment of unrecognized biases that may perpetuate racism, sexism, and/or social class inequalities. In other words, this process invites students to notice how their

allegiances are influenced and shaped by the larger culture in which they live, and how they themselves may have acted as agents of social oppression. Central to the work of Critical Aesthetic Pedagogy is the belief that when individuals become aware of how their allegiances perpetuate oppression, they will develop critical voices that can help them discuss systems of domination and notions of justice.

As critical aesthetic pedagogues, if we intend to teach in ways that empower students, we must also remain constantly involved in a process of self-reflective analysis of our own biases, and in a search for our own critical voices. It is only when we understand who we are, where we come from, and how our identities have been shaped by our culture that we can guide students through the process of finding their own voices, searching for self-actualization, and inventing their own ways of challenging social inequalities. This kind of groundwork also helps educators release some of their power in the classroom to their students and take the necessary risks to transform curricula into student-centered environments. This process is therapeutic, because as students learn to recognize connections between the issues they are studying and their own life experiences, they learn to affirm their lives, forgive past wrongs, and find closure—capacities needed to find agency for self and social change. This is the same process I described in Chapter One, using my own journey as illustration.

I do not mean to imply that the process of becoming aware and finding one's voice is simple, peaceful, or quiet. On the contrary, a critical aesthetic classroom is liable to become loud and conflictive, as students fill the space and time with relevant forms of exchange and discussion. Awareness evolves out of dialogue with others who hold divergent views, which helps students to understand that there are multiple ways of looking at the same issue. Discussions of this kind should always be encouraged, as long as they adhere to guidelines designed to ensure that the dignity of every person will be preserved.

It is my firm belief that academic study should serve as a tool to help students understand the world, promote self and social

empowerment, develop critical awareness, and challenge existing social inequalities. Educating students is a political act that can serve either to reinforce oppression and inequity using models that see the world as fixed and unchanged, or to challenge injustice by encouraging students to question the world and find ways to change it. A critical aesthetic model challenges all that we take for granted or consider ordinary and fixed, by inviting students to see the world as strange and unfamiliar. In this sense, Critical Aesthetic Pedagogy is concerned with teaching future educators that schools can provide a locus for resistance and social transformation, moving from the present and how it is, toward the future and how it should be.

Limitations of critical pedagogy

I have been teaching for ten years at both the undergraduate and graduate levels, and I feel that the critical pedagogical practices I employ help my students become more aware of issues of oppression and privilege, and the need to create social change. Nevertheless, my students continue to express profound doubt in their own power to make the changes that will lead to a more just and equitable society. They seem incapable of imagining what such a world would even look like.

This is what made me realize that critical pedagogy, as relevant and useful as it is, neglects important elements that are indispensable for the empowerment of students to create social change. Reflecting on my own teaching practice, I realized that although I had provided a safe environment for my students to share their experiences, question their world, and find their own voices, I had neglected to consider the influence of their previous schooling, which embodied what Paulo Freire (2000) calls the "banking concept of education":

> [In this method] the teacher issues communiqués and makes deposits which the students patiently receive, memorize, and repeat.... The more students work at storing the deposits entrusted to them, the less they develop the critical consciousness which would result from their intervention in the world as transformers of that world. (pp. 73–74)

Over time, this approach weakens students' faith in their power to shape their world, leaving them at the mercy of those in positions of authority, who tell them how to lead their lives. They thus become disconnected from what somatic theorists call their *soma* and its unique sensibility.

The *soma* represents a subjective view of our own thoughts, feelings, and emotions—in other words, a first-person perspective. Somatic Theory focuses on embodied experiences such as sensation, movement, and intention, which carry memories pertaining to our emotions. I believe that our understanding of the world is not restricted to our minds, but is also deeply embedded in our bodies, in the form of embodied memories. If we take a minute to consider it, we realize that what triggers recollection is not necessarily language or thought, but sometimes a smell, a sound, or a color. For example, when I listen to The Doors, I am reminded of my teenage years growing up in the Dominican Republic, skipping classes to go to the beach and watch the boys surf. I laugh when I smell the cologne White Linen by Estée Lauder, because I am reminded of long-ago mornings when my mother drove me to school, and as her scent pervaded the car, she would argue every day at the same corner with a different driver.

A disembodied experience is emotionless; it can be recalled by our memory, but this kind of sterile recollection does not arouse the feelings that accompany each experience that enters our lives. Somatic sensibility allows us to recall the emotions connected with our experiences, and this gives us a more visceral understanding of how they function in our lives.

Though somatic theorists have traditionally studied embodied experiences, some have shifted their focus to a wider socio-political realm. Jill Green (2001) refers to this area of study as "Social Somatic Theory...a field that addresses how our bodies and somatic experiences are inscribed by the culture in which we live" (p. 2). Peter McLaren (1998) describes this process as "enfleshment... [where we] can move beyond representation to participation...by recognizing the body as the primary site of meaning and resistance" (p. 244).

In my study of social somatic theory, I have found that it shares commonalities with critical pedagogy, one being the movement from personal experience toward cultural influence. Both of these approaches argue for the dismantling of the Cartesian dualistic notion of body/mind separation, favoring the mind over the body. This dualism holds that the body is no more than a machine to be objectified and thus separated from our experiences, and that the mind holds all our non-physical essence: "I think therefore I am."

Critical educational theory, as a liberating pedagogy, stresses the importance of using students' experience as an important curricular tool to help them understand how their identities are shaped by the culture in which they live. However, this pedagogical practice perpetuates the dualism of body/mind separation by failing to recognize the body as the site where identity is shaped, manipulated, and marked by culture.

As I have described previously, students come into our classrooms already accustomed to the banking method of education, in which their individual ways of interpreting the world are disregarded and the learning process is detached from personal experience, which inhibits the development of critical awareness. Critical pedagogy improves on this model by encouraging students to use their experience as a path to creating meaning and understanding their identities, but it disregards another fundamental aspect of the learning process: how our physical memories are marked by the culture in which we live, and how our bodies serve as vehicles to interpret our experiences. Excluding the body from critical discourse thus amounts to objectification of cultural experience.

While critical pedagogy may help develop students' critical awareness, it falls short of empowering them to create social change, because it ignores the body as a primary site for shaping knowledge. Instead it continues to weaken the vital connection between cultural experience and our somatic sensibilities, or what I prefer to call our *body authority*.

Body authority is the visceral feeling that helps us distinguish what is fair from what is unfair. Disconnection from this vital in-

ner resource leaves us feeling insecure and doubtful of our capacity to make decisions, so we are more likely to let others decide for us. Accustomed to learning what is fair and unfair from outside sources, we tend to assume that change is beyond the realm of our capability, and our capacity to see ourselves as agents of change becomes limited or incomplete. We are reduced to merely feeling sorry for those affected by injustice, because we feel powerless to help them. What is worse, this sense of disconnection inhibits our ability to even imagine change.

My students often say: "Yes, it's terrible, but what can we do?"; "That's just the way things are"; "In a perfect world things could be different, but this isn't Utopia"; "We can't do anything about that, we have no power"; "We have no control over that"; or " It's always been that way." When asked if changes in dominant systems are possible and if they see themselves as potential agents of those changes, they respond with a deep and unified "No." My students see themselves as the victims of history, not the creators; as people to whom things happen, not people who make things happen. In order for them to alter this perception, they must be able to think of themselves as agents of social change. They need to be able to see into a future that is yet to be created.

Here lies one of the biggest challenges of an educator: students' disconnection from their body authority hinders their capacity to imagine. While they may be sharing their experiences in class, linking them to issues of oppression, and understanding the need for change, they still feel powerless to create these much-needed changes because they cannot imagine a better future. The disconnection these students have felt for years between their experience and their body authority has shattered their belief in their own power to create changes for themselves and others. If one cannot imagine what a different world would look like, one cannot believe in one's own capacity to create it.

I am one to believe that without imagination there is no hope. We are all born with the capacity to imagine, which is a mental function but also an emotional one. Yet in order to experience and fully express this power we need to be in an environment that wel-

comes and fosters such growth. Because our students spend years being socialized and educated in a school system that does not allow them to expand their imagination, it withers from lack of use. For imagination to thrive, we must inculcate creative habits, create a supportive milieu, and provide encouragement that traditional classrooms do not offer.

Greene (1995) defines the imagination as the "ability to look at things as if they could be otherwise" (p. 19). This is the skill displayed by the interior designer who walks into an empty room and creates a mental image of how s/he wants it to look, then works toward the realization of that image. We must be capable of imagining the world we want to create before we can see ourselves as "designers" of a better society. Until we are able to imagine what is yet to exist, there is nothing that we can do to change the status quo or, for that matter, to create anything new.

This realization led me to the first of two defining concepts that must be taken into account in developing a successful Critical Aesthetic Pedagogy: *Imagination illuminates the path toward possibilities.* No matter how urgently and sincerely a progressive educator may intend to develop students' social awareness and empower them to create social change, if students cannot imagine a more just society, they will only learn to feel pity for those in need of aid. Pity is the realization of others' suffering without the intention to alleviate their distress; it separates us from those who are suffering by making them seem weak and inferior. The hegemonic forces of oppression actually depend upon our sense of pity to help maintain the status quo, because it allows us to let others decide how we should help those who are powerless in our society.

The capacity to imagine challenges those in power and those who wish to control the future. It enables us to take charge of our lives, and to understand how our actions can impact the lives of others. It allows us to see into the future by interpreting the past, and to construct plans and projections based on what we have learned. Imagination moves us from being stuck in the everydayness of life to having a purpose we believe we can fulfill.

After realizing that imagination illuminates the path toward possibility, I became concerned that awakening the imagination of my students might not be enough: they must also feel the desire to build the new worlds they imagine. Greene (1995) asserts that "the role of imagination is not to resolve, not to point the way, not to improve. It is to awaken, to disclose the ordinarily unseen, unheard, and unexpected" (p. 28). Looking back at my own life, I've found that the experiences that have touched me most deeply and encouraged me to take positive action are those in which I perceived commonalities between my own suffering and that of others. They helped me understand that the pain of all who suffer from discrimination, prejudice, sexism, linguism (and so on) stems from the same root as my own pain. This rediscovery embraces the notion that all people are equally human and deserving of respect. It is the root of human compassion, which inspires us to reach out and alleviate the suffering we see around us.

Maxine Greene (1995) describes compassion as the difference between seeing other people as small and seeing them as big. When we see people as small, we are looking at them from a detached-distant perspective. They seem weak and inferior, and we do not feel moved to alleviate their pain. On the other hand, when we see people as big, we see them in their full humanity and worth. To see people as small is to see them with pity, but to see them as big is to see them with compassion.

By this road I came to the second defining concept for Critical Aesthetic Pedagogy: *Compassion gives us the desire to embark on the path toward change.* Awakening students' imaginations will teach them how to dream the world as a better place, and with compassion they will feel the need and the strength to make these dreams come true. The combination of imagination and compassion is what gives us our power to create and recreate our world for the better of us all.

Aesthetic experience as a teaching tool

At this point I had laid the theoretical groundwork for my new pedagogical approach, but the question of practice remained. What educa-

tional tools could I use to enhance students' imaginations and help them feel compassion? Traditional teaching methods offered no solutions, and critical pedagogy could only take my students part of the way. The answer came from my own experience of artistic encounters that made me feel a visceral emotional response while engaging my mind in active, creative contemplation. Could aesthetic education offer the missing element to link my students' dreams of social justice with the real world of productive action?

Maxine Greene (2001) defines aesthetics as follows:

> ...a particular field in philosophy, one concerned about perception, sensation, imagination, and how they relate to knowing, understanding, and feeling about the world...an adjective used to describe or single out the mode of experiences brought into being by encounters with works of art. (p. 5)

An aesthetic experience can then be defined as the relationship created in the space between an observer and a work of art, and the way this artwork affects the observer. It is a moment of perception when our senses are functioning at their peak, because we are fully aware and fully awakened by the artwork in front of us.

To analyze this point of connection, I will borrow Susan Stinson's (1985) description of three levels of aesthetic experience that demonstrates how different types of experience yield varying levels of individual response. If we are to use artistic encounter as a teaching tool that will lead students toward a sense of social empowerment, we need to be very careful in selecting appropriate artworks and crafting encounters that will produce the desired results. Stinson's analysis can help us to hone our curriculum in applying a critical aesthetic approach.

Stinson's first dimension of aesthetic experience is limited to appreciation of the particular beauty of the artwork. According to her analysis, the observer is not moved at this level of perception, because the artwork bears no connection with his/her previous experience. For this reason, the first level of aesthetic experience cannot release the imagination or engender compassion in the observer. This is analogous to the banking method of education, in

which students are limited to storing new information without ap-
plying critical thought or interpretation. Sadly, it is also the kind
of aesthetic experience our public school students are offered in
conventional art education programs that follow formulaic and
standardized curricula.

Stinson's second level of aesthetic experience concerns the way
in which the artwork moves the observer. The effect the work will
produce in this dimension depends upon the life experiences that
different observers bring to the encounter, and thus upon the de-
gree to which they can relate to the piece in question. Some will
describe this level of experience as a transcendental moment in
which they discover their connection to their own body authority,
and this kind of primal reconnection can give people the strength
and security to create positive change in their lives.

I have seen this process in action during the course of a
research project in which I studied how salsa dancers, myself
included, learn to develop the body authority necessary to move
toward positive change in their lives. The narratives of the dancers
interviewed revealed how they had created meaning from the
transcendental moment in which they had found salsa for the first
time, and how this moment shaped the rest of their lives. The
dancers learned to utilize the dance as an embodiment of passion
and commitment to self-empowerment; some found the strength to
stop drinking, terminate bad relationships, lose unwanted weight,
or combat clinically diagnosed depression and chronic fatigue
syndrome. Susan Stinson (1985) describes this kind of
transcendental experience as a "source of knowledge of God and a
major source of meaning in life" (p. 77).

Though I would certainly not wish to devalue the positive ef-
fects that can be felt at this second level of aesthetic experience,
the particular type of encounter I am seeking must also be able to
engender concern about social inequalities, and desire for social
change. Self-empowerment is a necessary first step, but it is not
the final goal of my method. Aesthetic experience at Stinson's se-
cond level can release the imagination and allow the observer to
see a path toward a better life, but it does not encourage move-

ment beyond the personal into the social realm. It fails to engender compassion. For this reason, I agree with Stinson's (1985) concern that "transcendent experiences may too often simply refresh us—like a mini vacation—making us better able to tolerate some things which we ought not tolerate" (p. 78). Without compassion, social enlightenment will have no relevant effect.

Stinson (1985) describes a third level of aesthetic experience that strengthens the relationship between the observer and the world around her/him. The work of art becomes a vehicle for appreciating other people's suffering and connecting it with our own. She quotes Maxine Greene:

> Certain works of art are considered great primarily because of their capacity to bring us into conscious engagement with the world, into self reflectiveness and critical awareness, and to a sense of moral agency, and it is these works of art which ought to be central in curriculum. (Greene, cited in Stinson, 1985, p. 79)

It is my belief that in order to create an environment in which students can reach this third level of aesthetic experience, we must expose them to participatory encounters with works of art that possess certain qualities that encourage the sharing of experience and the recognition of common sources of oppression. These encounters must involve the body as a mediator of experience and employ its language to explore the work of art, because this is the only way in which we can truly appreciate the human emotions that are represented in the work. This kind of aesthetic experience allows us to embody the emotions portrayed and helps us to *feel* what the artist means, rather than simply seeing or hearing it. We can actually experience the emotions of happiness, fear, distress, anger, sadness, and so on, that the artwork engenders, and this visceral connection evokes discussions of the human condition.

The third dimension of aesthetic experience prompts us to evaluate our own life experiences in light of the human condition as it is represented in the work of art, and to explore our potential to bring about change. Encounters of this kind have an extraordinary capacity to release the imagination and engender compas-

sion, because they engage our personal experience at the bodily level. This reconnects us to our body authority, which is the source of self and social empowerment.

Creating this type of aesthetic experience in an educational context is of utmost importance for a successful Critical Aesthetic Pedagogy. On the one hand, this process helps students to understand how oppression affects them personally, which will allow them to initiate a healing process. On the other hand, students can use this critical lens to see how they have oppressed others, whether consciously or unconsciously, and thus to discover commonalities in all human suffering. The awareness they learn through this kind of encounter will eventually empower them to create social change.

Critical Aesthetic Pedagogy

My awareness of the missing dimensions in current educational theory led me to trace the connections between imagination, compassion, and empowerment. Through my work in the arts, I have been able to witness the immense power of aesthetic experience to release and engage these elements in a process of profound personal awakening. It is at the intersection of these currents of thought that I laid the foundations of *Critical Aesthetic Pedagogy*. This new method shows how the arts can be used to enhance students' social and critical consciousness to the point of achieving self and social empowerment.

In the following chapters I will illustrate how Critical Aesthetic Pedagogy works in my classrooms, using the examples of two aesthetic encounters that I have incorporated into the curricula of undergraduate Social Foundations of Education courses. This is just a sample of the many ways in which my educational model can function in practice. Educators are encouraged to draw inspiration from their own experiences and from the context of their courses and classrooms, to create the types of encounters that best serve their students. Critical Aesthetic Pedagogy is all about using the tools we have and creating the tools we need in order to expand our students' horizons. It is pedagogy of possibility.

CHAPTER THREE

Critical Aesthetic Pedagogy in Action

As I have described, the object of *Critical Aesthetic Pedagogy* is to infuse aesthetic experience into critical educational practices in order to enhance capacities that are indispensable for students' self and social empowerment. By exposing students to participatory encounters with works of art possessing certain qualities that encourage the sharing of experiences and the recognition of common sources of oppression, educators can create a sense of empowerment that will help students enable social justice. These encounters must rely on the body and its language as mediators for understanding how personal experiences of culture, gender, and social class can shape one's identity, and how unexamined adherence to social identity can perpetuate systems of domination. This embodied process enables students to recall the feelings that have accompanied their own oppressive experiences, which gives them a more visceral understanding of how these experiences continue to function in their lives. Through this process students can reconnect with their body authority, a source of empowerment to alleviate the oppression that afflicts them and others in society.

In this chapter I will explore the critical aesthetic process as it functions in a classroom setting. First I will describe my experiences as a participant in the Lincoln Center Institute's Aesthetic Education Program, whose main goal is to "integrate aesthetic education into teacher preparation programs in order to ensure that the arts and imagination will assume an essential place in the education of children" (Holzer, 2005a, p. 133). The insights I gained through my involvement with this program, combined with my previous knowledge of critical pedagogical practices, supported my

development of Critical Aesthetic Pedagogy as an alternative teaching modality.

Next I will discuss the research methodology and design of a study I conducted to determine the efficacy of my critical aesthetic method. Finally I will describe sessions of Critical Aesthetic Pedagogy I deployed in undergraduate Social Foundations of Education courses offered at widely differing colleges in the City University of New York system, and analyze the results. The first case study is of a senior college located in Queens, a less-populated area of New York City, and the second is of a community college in downtown Manhattan. Although the student populations vary greatly between these schools, the results of my research demonstrate that critical aesthetic methods can be equally successful regardless of students' socioeconomic and cultural backgrounds.

The Lincoln Center Institute and the Aesthetic Education Program

For more than thirty-five years the Lincoln Center Institute (LCI) has been developing a unique approach to education that challenges participants to expand their knowledge of the world through the study of the arts. Working in partnership with educators and teacher education programs, the Institute develops experiential studies focusing on specific artworks in the genres of dance, music, theater, visual arts, and architecture. The LCI's approach is based on the ideals of Mark Schubart, the Institute's founder, and the writings of Maxine Greene, the Institute's Philosopher-in-Residence. Greene's work is based in turn on the writings of pragmatist John Dewey and several other existential philosophers. Starting from Greene's (2001) point of reference, the Institute has developed its own unique practice of aesthetic education:

> Aesthetic education...is the intentional undertaking designed to nurture appreciative, reflective, cultural, participatory engagements with the arts by enabling learners to notice what there is to be noticed, and to

lend works of art their lives in such a way that they can achieve them as variously meaningful. (p. 6)

Maxine Greene has inspired teachers to think in new ways about the aesthetic encounters offered at the Institute. She urges educators to transform their own learning experiences into innovative classroom teaching practices that recognize perception, cognition, affect, and imagination as additional ways of knowing. Participants in these activities are encouraged to integrate prior life experiences into their new understanding of a particular artwork, and often, of their world.

The LCI offered a vital spark to the critical aesthetic process I described in the previous chapter. Each artwork in their repertoire is explored through workshop activities designed by a participating "teaching artist" to help students understand the creative process and connect the artist's perceptions to their own life experiences. During these workshops, participants are invited to observe, listen, and make choices that will help them embody the emotions represented in the featured work of art. With no limitations imposed in the form of "right" or "wrong" answers, this process develops each individual's ability to think in new and different ways. As a result, unexpected connections are made, alternative viewpoints are considered, and doors to unimagined worlds are opened.

For the development of its Aesthetic Education Program (AEP), the Lincoln Center Institute has created three different types of collaboration with New York City educational institutions: partnerships with K–12 public schools, partnerships with colleges and universities, and collaborative creation of new charter schools. These charter schools have aesthetic education ingrained into the very fabric of their curriculum; every teacher and pupil is involved in the process, and K–12 teachers are teamed with performers and specialists in the visual arts. In the partnerships with public schools, participation in the Aesthetic Education Program is open to all teachers and administrators, but none are required to join. For the partnerships with colleges and universities, the LCI offers

a variety of consultancies, workshops, and online courses, and a Teacher Education Collaborative. This group works directly with faculty and students from teacher education programs to develop effective aesthetic education practices for the classroom, and places student teachers in the LCI charters and partnership schools.

As a faculty member in the Elementary and Early Childhood Education Department at Queens College and later in the Teacher Education Department at the Borough of Manhattan Community College, I was involved in the LCI Teacher Education Collaborative for several years. It was during this time that I became interested in exploring the use of artworks as educational tools, first drawing on the LCI repertoire, and later taking advantage of the many artistic venues in the New York City area. My goal, as I have previously described, was to expose students to particular types of aesthetic experience as a way of enhancing their imagination and compassion, to help them envision the possibility of creating social change.

During the years when I participated in the LCI Aesthetic Education Program, I was exposed to numerous artworks from their repertoire, and participated in the associated workshops. Faculty involved in the collaborative joined in discussions of assigned readings to help us better understand the aesthetic process. The LCI refers to these readings as "contextual materials," and they include book chapters and articles by Maxine Greene, Phillip Jackson, and John Dewey, among many others. For each artwork we also read and discussed its *Windows on the Work*, a booklet published by the LCI to facilitate the study of each artwork in its repertoire. These booklets comprise relevant materials designed to provide educators, teaching artists, and students with contextual information pertaining to the work of art being studied.

The LCI's aesthetic educational model offered an effective way of incorporating artistic experiences into any classroom setting, and the training they provided was instrumental in shaping my pedagogical method. In the pages that follow I will describe in more detail my professional development as an LCI Aesthetic Ed-

ucation Program participant and the methods I have adapted to suit the purposes of Critical Aesthetic Pedagogy.

Professional development at the LCI

During my first year at the LCI, I was involved in what is known as an intensive "professional development" experience. This is a period during which participating educators explore works of art from the LCI's repertoire with the guidance of a teaching artist. These artworks are selected based on their potential for exploration from multiple perspectives, and the ease with which they can be incorporated into education courses. Artists leading the workshops draw on their own creative experience to recreate elements of the artistic process, with the aim of enhancing the participants' aesthetic development. Participating educators are exposed to a series of artworks, aesthetic workshops consisting of art-making explorations, and contextual materials related to each work of art studied.

After reviewing the contextual materials, workshop participants are presented with the selected work of art, which can be a photograph, painting, sculpture, or play. The workshop concludes with a wrap-up of the whole experience, or what is referred to as "pulling back the curtains" of the aesthetic education process. Here participants discuss various issues and questions pertaining to the artwork, as well as the aesthetic education methodology employed in the workshop.

Over the course of seven years I participated in several LCI workshops, each of which included exploration of contextual materials, viewings of the selected artwork, and a final wrap-up session. The process was different for each workshop, depending on the teaching artist's interests and artistic background, the faculty involved, and the work of art under review. Nevertheless, as Holzer (2005b) states, all of the LCI workshops bear a number of hallmarks. Among these are the following:

- Selection of a work of art for study that is rich in possibilities for exploration;

- Collaborative brainstorming of many possible entry points into the study of an artwork;
- Creating of a generative question, known as the "line of inquiry," as a beginning point for the exploration;
- Exploration workshops before experiencing the work of art;
- Use of contextual materials throughout the exploration process;
- Conversations punctuated by questions leading to description, analysis, and interpretation;
- Student-centered active learning that acknowledges each participant's prior knowledge and life experiences;
- Use of multiple learning modalities in each exploration;
- Creation of vocabularies—verbal, visual, physical—that can be used to describe a work of art;
- Experiencing the work of art more than once;
- Group and individual reflection throughout the exploration and after a performance or a museum visit;
- Validation of multiple perspectives in the creation of individual and group understanding;
- Connections to the classroom curriculum and pedagogy; and
- Opening out of new possibilities for learning that includes generating new questions to be explored. (p. 2)

After devoting a year to the LCI professional development program—studying the LCI philosophy of aesthetic education, viewing artworks from their repertoire, and attending faculty workshops—I became an active part of the collaborative and developed sessions of my own using the LCI model adapted to the purposes of Critical Aesthetic Pedagogy.

Developing a Critical Aesthetic Pedagogy session based on the LCI model

My exposure to numerous works from the LCI collection had provided a wide variety of pieces from which to select the ones I would

most like to bring into my own classrooms. After choosing a work of art, the next step was to meet with an LCI teaching artist for a brainstorming session about the artwork and its place in my curriculum. Two important elements of the aesthetic education process were developed at this meeting. The first of these was the cre-creation of what the LCI refers to as the "line of inquiry," which is found at the intersection of the artwork, the course content, and the teacher's personal interests. The second was the design of classroom activities that would help students to understand the key features of the artwork.

During this meeting I explained my philosophy of education to the teaching artist and described the key elements I considered necessary for my planned approach to the material, based on the principles of Critical Aesthetic Pedagogy. First, I emphasized my concern for allowing the students to bring their own experiences into the classroom and link them to the issues of oppression to be discussed in the course. Second, I described my interest in a pedagogical approach that includes the body as a mediator of experience and employs its language to explore the feelings that arise. I explained my belief that this method can help students develop the compassion and imagination necessary to create social change. I requested that we prepare the line of inquiry and plan the workshops in a manner that would reflect this philosophy, which I believed would help my students to develop a passion for social action.

My aim was to adapt the LCI model, which employs works of art that are open to multiple interpretations, shaping it to the purposes of Critical Aesthetic Pedagogy by focusing on artworks with specific agendas, to facilitate discussions about social justice. My theory was that exploring artworks that engage issues of suffering, oppression, and discrimination would help students to analyze themes that are typically discussed in critical pedagogical classrooms. Workshop participants would then be encouraged to engage in the art-making process in a space where they could feel safe to share their own experiences of oppression and discrimination, and this would allow them to connect with their own power to

change the world.

I incorporated the sessions I developed during this period into two undergraduate courses in Social Foundations of Education that I taught at Queens College, City University of New York, and gathered data from these applications for a research project testing the validity of my new methods. In the following sections I will discuss the foundations and methodology of this study, the results of which I will later present in detail.

Foundations of My Research

Aesthetic experience differs in its effect depending upon what each observer brings to the encounter, and I understand that my own interest in the aesthetic educational approach stems from the feelings of social inadequacy that haunted me during my formative years. Because I was raised in a culture that separates people according to family wealth, and because I felt alienated from this environment, I found myself searching for a space of social acceptance, which I finally discovered in dance classes. The reason for this, as I later understood, was that the dance classroom provided the only social environment in which I felt unquestionably accepted, regardless of my background. The dance floor was the first space where I encountered equality and social empowerment.

This welcoming atmosphere gave me a new sense of security and helped me develop the strength to create changes in my life. Furthermore, I believe that my involvement with the arts allowed me to imagine possibilities that would otherwise have seemed entirely beyond my reach—and this idea inspired my development of Critical Aesthetic Pedagogy. The operating principle of this approach is that exposing students to specific types of artistic expressions in a structured and welcoming environment can allow them to connect with their own power to change the world.

In order to determine whether aesthetic education practices can complement or enhance critical pedagogy in the development of students' social empowerment, I devised a narrative study to test the principles of Critical Aesthetic Pedagogy using the teach-

ing sessions I developed at the LCI as a foundation for my analysis. In this chapter I will present an overview of my research and its results.

Why a narrative study?

According to Kohler Riessman (1993), narrative analysis addresses the ways in which protagonists interpret experience: "The purpose is to see how respondents impose order on the flow of experiences to make sense of events and actions in their lives" (p. 2). The goal of my study was to investigate whether Critical Aesthetic Pedagogy can support the development of students' capacity for compassion and imagination, two qualities that can enable the pursuit of social justice. This educational process can easily be tracked by studying students' individual interpretations of specific aesthetic experiences, the ways in which they create meaning from them, and how they intend to utilize their new knowledge when confronted with similar situations.

The tool I used to assess the ultimate success of Critical Aesthetic Pedagogy in this case was my students' writing assignments. These consisted of narrative papers or journals in which students were asked to reflect on assigned readings and related class discussions in the light of their own personal experiences, using a particular artwork and associated classroom activities as a backdrop. My instructions for their final paper were as follows:

> Throughout the semester we have talked about different issues related to education. In your paper, you should use the semester's chosen work of art and workshop activities as a backdrop to your reflections on the assigned readings, along with the respective class discussions and your related personal experiences. Some of you may choose to emphasize some aspect of your experience with the work of art, and this is acceptable as long as you provide a smooth transition between topics, issues, and concerns. Most importantly, your paper should be insightful, well written, and grammatically correct.

I conducted a narrative analysis of these reflective papers, looking for recurring themes that indicated an enhanced critical awareness and empowerment to pursue social change.

I purposely constructed this assignment to be as open-ended as possible, and I withheld one important piece of information—I did not mention what I was looking for in their narratives. I made this choice for several reasons. First, if I told my students what I was hoping to see, they would likely make sure it appeared in their papers, and this would cloud the effects of my study. Second, I wanted to allow students the freedom to draw connections between the theoretical class materials, the effects of being exposed to the artwork and related classroom activities, and their own prior life experiences, so they would begin to develop a personal sense of empowerment. Third, I believe that when individuals are allowed to speak freely about their experiences, the elements they consider most relevant and meaningful will naturally arise in the discussion. As Kohler Riessman (1993) writes:

> *Human agency and imagination* [italics added] determine what gets included and excluded in narrativization, how events are plotted, and what they are supposed to mean. Individuals construct past events and actions in personal narratives to claim identities and construct lives. (p. 2)

I emphasized human agency and imagination in this quotation because these are elements that Critical Aesthetic Pedagogy aims to enhance, with the goal of empowering students to create social change.

Establishing the validity of my research methods

In conducting my research projects for this book, I followed the protocols of the CUNY Committee for the Protection of Human Subject Institutional Review Board (IRB). As part of the IRB review process, I created a consent form for my students to sign confirming their agreement to serve as participants in a research project. This form clearly stated that non-participation on their

part would in no way affect either their final grade or their CUNY academic standing. The consent form explained the purpose of my research, withholding only the type of narrative I would be looking for in the final papers. It also stated that students would be free to withdraw from participation in the research project at any time.

I recognize that my position as both the researcher and the professor of the course, wielding the power to assign academic grades for the work completed, could put the validity of my research in doubt. Kohler Riessman (1993) would agree, as she has stated: "Meaning also shifts because it is constructed in a process of interaction.... The story is being told to particular people; it might have taken a different form if someone else were the listener" (p. 11). To reduce the influence of my position of authority, I included in the consent form a clause that stated the following:

> All signed consent forms will be kept in a sealed folder until final grades are posted at the end of the semester. After grades are posted, the principal investigator will proceed to select the papers of those students who consented to be part of the case study.

I must emphasize that my experience in educating future inner-city teachers has been that these students bring to the classroom high levels of ethics and honesty and an immense desire to create positive change in the lives of the children they will teach— they just don't know how to go about it. Here is where I believe that Critical Aesthetic Pedagogy can help—by opening new possibilities before them and affirming their power to make the changes they so passionately desire.

In the following sections I will present two examples of what Critical Aesthetic Pedagogy looks like in a teacher education classroom. I will describe the chosen works of art, the foci of the courses, the lines of inquiry and study questions developed to guide the sessions, and the accompanying workshop activities. I will illustrate my presentations with selections from participating students' narrative writing, which I tracked to assess the effectiveness of my methodology, and with detailed analyses of

individual and group reactions to workshop activities. Finally I will discuss the recurring themes that arose in students' narratives indicating enhanced critical awareness and empowerment to pursue social change.

The passages I have selected for analysis in the case studies represent the most original expressions of students' self-reflective process. Many other examples from my students' writing success-fully incorporated the issues and themes that were the focus of the course and of my analytical study, but relied heavily on the termi-nology used in course materials. The selections I have included best demonstrate that students have internalized the concepts presented in the critical aesthetic sessions, and have created meaning from the course material that is relevant to their own lives.

Critical Aesthetic Pedagogy Sessions at Queens College

The first case I will describe is of two undergraduate Social Foundations of Education sections at Queens College, City University of New York. During the years when I taught at this school, it served 17,639 students living in the neighboring suburban areas. Almost 3,000 of those students were enrolled in various Teacher Education programs in the School of Education. Most of them were women who fit the overall self-reported college demographics of 10% Black, 15.8% Latinas/os, 55.3% White, 18.8% Asian or Pacific Islander, and 0.1% American Indian, and only 9% of the incoming students who responded to a survey reported living in families whose total annual income was under $25,000.

Setting the stage: Selecting the featured artwork

For both of the sections studied I employed teaching sessions I had designed during the period of my active involvement with the Lin-coln Center Institute's Aesthetic Education Program. These ses-sions featured the study of Anna Deavere Smith's *Twilight: Los*

Angeles, a documentary drama set in the violent aftermath of the 1992 Rodney King trial and verdict, whose specific goal is to encourage viewers to talk about discrimination in America. Smith composed her piece entirely from interviews, songs, and visual materials (photographs, films, and pictorial documents) that she found in the historical record, and the play is structured as a mosaic of narratives spoken by individuals recalling their experiences during the riots. The speakers are portrayed using their own words, speech patterns, mannerisms, and styles of dress. We hear different voices drawn from a variety of social groups—Blacks, Whites, Asians, Latinos, gang members, jurors, secretaries, police officers, rich, and poor.

Students described the format of the play as follows:

The play "Twilight: Los Angeles" by Anna Deveare Smith consists of a series of monologues taken verbatim from her interviews with hundreds of individuals involved in or affected by the 1992 Los Angeles riots. In 1992, violence and destruction occurred in South Central LA following the trial of the four police officers charged with the beating of Rodney King. The four Los Angeles police officers were acquitted after being caught on a home video repeatedly clubbing Rodney King for a speeding violation. This verdict sent the city into an outrage causing all hell to break loose on the streets of Los Angeles. Buildings were burned and stores were looted, demonstrating the intensity of civil unrest in the community.

Anna Deveare Smith's "Twilight: Los Angeles" displays people's reaction to the incomprehensible verdict by presenting the motives of the riots based on anger and betrayal caused by racial tensions.

The importance of Twilight: LA is that the audience becomes involved in understanding a historical representation of diversity. The audience learns to recognize human nature through narrations of history told by the voices that participated in the riots.

Developing focus: Course structure and selected readings

I developed the syllabus for the two sections around the play's controversial issues of race, gender, social class, ability, identity, com-

pliance, discrimination, and privilege. Assigned readings were selected from *The Institution of Education* (2006), edited by H.S. Shapiro, K. Latham, and S. Ross. Students were expected to read the assigned articles before class, consider them in the light of their prior experience as students and their future role as teachers, and come to class meetings prepared to talk about them, utilizing the play as a backdrop for discussion. At the end of the semester the students were to write a final narrative paper in which they were asked to reflect on the entire semester's assigned readings and related class discussions in light of their own personal experiences, using the performances and activities as a backdrop.

Shaping the discussion: the line of inquiry

A cornerstone of the LCI aesthetic education model that I have incorporated into my approach is the articulation of an overarching line of inquiry and a series of study questions related to the focus of the course, to drive the discussion. These elements are intended to shape the students' encounter with the materials presented, and guide the critical aesthetic process. The line of inquiry and study questions developed for the Queens College sessions are presented below.

Line of inquiry. How does a series of events such as those captured in *Twilight: Los Angeles* polarize racial, gender-based, and class-driven identities? How does this performance attempt to reconcile this polarization? In giving voices to different perspectives, does it inspire dialogue, compassion, activism, or further resentment?

Questions that drive the line of inquiry.

- Do multiple perspectives allow us to feel compassion for the types of characters portrayed in the show?
- Does embodying other people's emotions bring compassion?
- Do particular works of art encourage people to define themselves in terms of particular identity groups, whether oppressed, marginalized, or mainstream?

- Does this show have a hidden agenda?
- What is identity?
- To what degree does Anna Deveare Smith's identity affect her technique/approach?
- What kind of dialogue does the show inspire?
- How do contemporary issues of race, gender, and social class affect the classroom community?
- Schooling occurs within diverse communities that must constantly struggle with racial tension and conflict resolution. How can this performance prepare future teachers to manage this kind of environment more effectively?

Exploring experience: the workshop activities

The articulation of the line of inquiry and its driving questions guided the design of the workshop activities to be held in my classroom one week before and immediately after the students viewed the performance. I dedicated the entire introductory class session of two and a half hours to the first workshop, and in collaboration with the teaching artist for the session, prepared four activities for individual and group work (Activities 1–4). For the workshop hour to be held immediately after the play we planned two more activities (Activities 5–6). A brief description of all six activities will follow.

On the day of the first workshop I introduced the teaching artist who would be facilitating the discussion. I explained that she was an actor, but had no part in the theater piece we were to study. She then asked the students what they knew or had heard about the 1992 Los Angeles riots. The students were well informed about the issue, although most of them had been very young when the events took place. They mentioned the beating of the Black man named Rodney King by four White police officers who were later acquitted of the related criminal charges. They also mentioned Reginald Denney, the White truck driver who was pulled from his truck and beaten on the streets, and the burning and looting of neighborhood stores owned by Koreans.

I then presented an overview of the theatrical piece that they were going to see and described Anna Deveare Smith's process of creating the play from interviews about the riots. When the introductory elements of the workshop were completed, we proceeded to the planned activities.

Activity 1: Gesture Explorations. (2 groups, 10–15 minutes). We began the session with a body warm-up. After clearing the room of chairs and desks, the students were separated into two large groups with rotating leaders. The leaders were to switch after completing the commands they would be given. Each team leader was instructed to perform gesture explorations, using operative commands that were thematically connected to *Twilight: Los Angeles.* The gestures used to express each command were to be explored in different tempos and ranges of motion, from simple facial expressions to full-body movements. The rest of the students were instructed to follow the leaders as a flock. The two groups were given paired commands representing contrasting but complementary concepts, such as "right" and "wrong," and each group was told to respond to the other. Thus, one group could be moving slowly to the command of *rage* while the other was executing full-range motions of *happiness.* The command pairs were as follows: revenge/complacency, riot/celebration, right/wrong, suffering/joy, shame/pride, and rage/happiness.

Discussion questions:

- What movement quality best articulates the experience of rage, celebration, etc.?
- How did the groups react to one another?
- How did opposing dynamics reconcile themselves?
- Which range of motion better connected to the way you would feel in this situation?

During this first exercise, the students seemed uncomfortable and out of place. Some kept their body movements to the bare minimum, almost invisible, despite our request to widen their range of

motion. Other students burst into nervous laughter and moved to the back of the flock to avoid becoming the leader. After the exercise, students confessed to feeling self-conscious and embarrassed at having to execute descriptive body movements and dramatize emotions. Some admitted that if they had been warned in advance, they would not have attended class on that day.

I explained to the students that the purpose of these exercises was threefold: First, to help them loosen up and experiment with the connections between moving, thinking, and feeling. Second, to make them aware that the discomfort they felt in connecting to their bodies was not uncommon, because we all have been educated to control our bodies, and to think what we feel, rather than expressing it physically. Third, to help them understand key elements of the theatrical piece they were going to see, which was bursting with a full range of extreme emotions. I assured them that this particular exercise would help them understand Anna Deveare Smith's process as she moved from transcribing the interviews to creating the work of art.

Activity 2: Reflective Writing. (Individual work, 10–15 minutes). The students were asked to describe an event that they had witnessed or experienced in school, either as a teacher or as a student, in which they or someone they knew had suffered some form of discrimination. They were told that their writing did not have to be in full sentences or grammatically correct, but that it had to include as many details as possible, to help conjure the memory of the event as clearly and specifically as they could. These details could include how the person in question was feeling, how they expressed their emotions, and what words they used to express themselves at that moment or right afterward. This reflective writing was to be used in the next exercises.

Activity 3: Moving Tableaux. (Group work, 15 minutes). In groups of four, students were asked to share their written experiences and to help each other create five-second scenes dramatizing each account. Each scene was to connect to the next, so that the

entire performance would progress wave-like through all of the students' experiences. The quartets were responsible for choosing which part of each experience to reenact, selecting the props they would use, determining the number of actors for each scene, and deciding how to connect one experience to the next. Students were provided with handmade frames (viewfinders) through which the observers could view the scenes and discuss what they saw, focusing on the inherent group dynamics, noticing the reactions and emotions of each group member, and trying to avoid asking "charades" questions.

Discussion questions:

- What were the dynamics created in each tableau?
- How did the members of each group connect their experiences together to make their performance flow?
- What did you notice about the movements and the use of space that made each experience seem different from or similar to the others?

For this exercise we specifically asked the students not to pose questions about any of the experiences they saw reenacted, and to avoid sharing their own experiences with members of other quartets. The object of this activity was for the students to notice the inherent dynamics of conflict situations, and to be exposed to multiple perspectives on the same type of experience. In this activity there were to be no right or wrong answers, only multiple interpretations.

The students made a number of interesting observations about this exercise, and there were as many interpretations of each account as participants sharing their opinions. A large number of students agreed that in general, the representations tended to show the "oppressor" figure on a higher physical plane or with a taller posture, and the "oppressed" was usually placed on a lower level, or shown holding his or her body in a hunched position. Students also commented that the quartets that were most successful at creating flowing connections between the different reenact-

ments seemed to be presenting a unified group experience rather than a patchwork of unrelated events.

Activity 4: Making a Monologue. (Group work, 1 hour). Remaining in the same quartets, students were instructed to select one of their stories to work on in greater depth, and to develop relevant questions that they would ask if they were journalists interviewing strangers about the event. Using a tape recorder, one member of each quartet interviewed the storyteller. Each interviewer then became an actor whose job was to enact the experience to the whole class. The third and fourth students in each quartet acted as artistic directors and were expected to study and document the gestures and voice patterns of the storyteller during the interview, so that they could later instruct the actor on how to present a dramatic monologue of the story to the class.

For the second part of this activity, the storyteller moved to a new quartet and became a documenter. Each group listened to the tape of the interview and transcribed the portion they chose to enact. The actor, with the assistance of the directors, was expected to recreate the vocal dynamics of the person interviewed (accent, vocal rhythms, and so on). The actors portrayed the story to the entire class, which then discussed the performance as a group.

Discussion questions:

- What kinds of questions were asked during the interview?
- Were the interviewers and actors objective?
- How did the different perspectives presented affect one another, and affect the audience?
- How did it make you feel to embody other people's emotions?

During this exercise the students seemed more at ease, and the room was filled with murmuring sounds and spontaneous laughter as they worked together in their groups. Watching the portrayal of the experiences, the students in the audience were silent and attentive. The actors, while admitting that they felt self-conscious

about performing in front of a crowd, expressed more concern with honoring and respecting their peers' experience than with their own discomfort. They feared that a poor performance on their part would mock the emotions expressed during the presentation. The most interesting comment came from a student/actor who said that although he could never fully know how his peers had felt during and after their experiences, portraying their memories had helped him step into their shoes and feel similar emotions. The other student/actors concurred with this comment.

Activity 5: Creating a Collage. (Individual work, 30 minutes). After viewing the performance, students were given magazines, newspapers, construction paper, scissors, and glue, and were instructed to create a collage with words and images that captured the dynamics of the events in Los Angeles. We encouraged them to explore surprising juxtapositions of color and shapes. We placed all of the finished collages in a gallery, to be examined and discussed. These collages eventually became the cover sheets for the students' final papers.

Activity 6: Summary and Review. (Whole class, 30 minutes). We closed the event by "pulling back the curtains" on the entire workshop process. We discussed the performance and the critical aesthetic theory that had informed the line of inquiry and the related discussion questions.

Students' reactions to the theatrical production of "Twilight: Los Angeles"

The students indicated that they had been impressed by the power of the play and its message. Their reactions were passionately expressed, not only during the wrap-up session, but in their final papers as well. Here are some examples from their narratives:

> *When I first walked into the little theater in the Lincoln Center Institute to see a performance of Twilight: Los Angeles, by Anna Deavere Smith, I had no idea what to expect. When I looked at the nearly empty stage and*

the barefooted actors I thought that I was in for a second rate performance, I certainly didn't expect to be as profoundly affected by it as I was.

The actors were amazing in their multitude of roles, each portraying a range of emotions that forced me to sit up and take notice. Through their words, actions, and even moments of silence I was able to really "hear" what they were trying to say, something I didn't do in 1992. They took an event that happened eleven years ago and made it real and relevant to lives of people today.

As I sat and watched the performance of Twilight Los Angeles I had an empty pit in my stomach. Where did all of that anger come from, and how do we prevent the L.A. riots from happening again?

Whether it be education or the Rodney King riots, we as people perceive things differently. What I saw as a revolution, others saw Blacks destroying their own communities. "Twilight Los Angeles" made me see the riots in a whole new perspective. I did not know that the Rodney King riots were so tremendous! I also was greatly informed about the origins of the riots.

As I watched the performance along with the recorded live footage of the Rodney King beating and the riots, I too could feel the pain and emotions of the unheard voices.

Smith was trying to reach the core of humanity and wanted to tell us that the solutions to our problems lie in the collaboration of individuals. She was not trying to propose to us a specific solution to social problems, since these lie in the hands of activists, legislators and most importantly in us—the audience.

This play significantly expanded my horizon by "reading between the lines" of each character as an individual with particular motives and I was astonished by the method of one character shared by two actors. That definitely raised eyebrows as far as realizing that as much as people don't think they generalize, sometimes one can be surprised. Ignorance is a word most would not relate to but most possess. Instead of turning away from ignorance one should ignite this word into a different meaning. Ignorance should be viewed as the never-ending odyssey to obtain knowledge. The message of this play is ambiguous to everyone, but one thing is clear, it will impact an idea.

*In some of the scenes they performed they made me feel really emotional. I
wanted to cry in some of the scenes.*

Analysis of recurring themes in students' narratives

Within my students' written narratives, I found six recurring
themes that demonstrated a new critical awareness, growing com-
passion, and a sense of empowerment to create social change. The
themes I identified were as follows:

(a) Critical awareness in describing the theatrical production
(b) Critical awareness in connecting the theatrical production
 to the course assignments
(c) Deepening compassion evidenced by use of the metaphor
 "putting on someone else's shoes"
(d) Deepening compassion evidenced by identification with a
 particular group of characters in the play
(e) Critical awareness in describing their own future roles as
 teachers
(f) Empowerment to change social inequalities, starting in
 their own classrooms.

I will briefly discuss each of these themes in turn, analyzing their
importance in the context of a critical aesthetic classroom.

*(a) Critical awareness in describing the theatrical
production.* The first important theme that I identified in my
students' narratives was a growing awareness of social injustice.
This was exhibited in their descriptions of particular parts of the
theatrical production, and the impact these moments had on them
as spectators. Quotations expressing this new awareness can be
found on pages 69, and 70 of this chapter. This group of quotations
demonstrates the power of the aesthetic moments created between
the spectators and the performance, and how they affected the
students in light of their own social backgrounds and life
experiences. In this case, the work of art became a vehicle for

appreciating other people's suffering and connecting it with their own.

These quotations feature emotionally expressive language and exhibit an appreciation of the human emotions represented in the play. Expressions such as "profoundly affected," "even in moments of silence I was able to hear," "an empty pit in my stomach," "feel the pain and emotions of the unheard voices," "made me feel really emotional," "it raised eyebrows," and "trying to reach the core of humanity" demonstrate a strong embodied connection to the work of art. These emotional expressions are evidence of the students' initial steps toward reconnecting with their body authority. This process can help students recall emotions connected with experiences from their own lives that are echoed in the artwork, which gives them a more visceral understanding of common sources of oppression, and how they all share the same root of human suffering. The next step in the critical aesthetic process is developing the imaginative capacity to find ways of alleviating this pain.

(b) Critical awareness in connecting the theatrical production to the course assignments. This theme arose as the students related the theatrical production to the various course materials and activities, and it is exemplified by the passages quoted below. These excerpts confirm that the assigned readings used as contextual materials, the class discussions, and the planned activities designed with the help of the teaching artist all functioned as successful components of the critical aesthetic process.

> *Connecting the readings with Twilight L.A. turned the play into a more realistic form of questioning and a bunch of what ifs. These readings are very helpful for teachers and students but most of all very helpful to everyday knowledge.*

> *The performance on the story of the Rodney King incident on March 3, 1991 was a real eye opener for me. After seeing the performance I feel as if the whole semester tied into this performance in some way.*

Throughout the readings, discussions, and the performance at Lincoln Center this course has opened my eyes to be more aware of the diversity and the discrimination that still exists today. The most important factor I learned is to become aware of my surroundings and to better understand how all children have many different experiences in life and I must try to involve them in the curriculum.

The "Twilight: Los Angeles" performance along with the readings and the discussions we reflected upon in class will help me to serve my future students with a greater insight and understanding of the struggles and challenges all children, especially minority students, face in the classroom and in everyday life.

Reading the various articles we did during the semester, activities, and seeing the performance at Lincoln Center informed me on the different circumstances I'll have to deal with in the teaching world.

The articles I have read during the semester have been exceptionally enlightening. Watching the play "Twilight: LA" has enhanced my perception because of the knowledge I have acquired during the semester.

(c) Deepening compassion evidenced by use of the metaphor "Putting on someone else's shoes." The production featured four actors who crossed gender and race barriers to portray a variety of different characters. The actors alerted the audience to their changes in role by taking off the shoes they were wearing and putting on a different pair, a technique that fascinated the students. To put on someone else's shoes means to let go of one's own biases and complaints in order to enter another person's reality and feel their pain. A large number of students used the metaphor of "putting on some else's shoes" to describe their future role as teachers, emphasizing the necessity of teaching children to be compassionate individuals.

Throughout the play the actors changed their shoes or took off their shoes. I viewed this changing of shoes as if the actors were literally "putting themselves in someone else's shoes." This theme was depicted throughout the play and I couldn't help but relate this back to being a teacher.

Teachers also need to "put themselves in their students' shoes." It is crucial for teachers to constantly be aware and conscious of the individuality amongst their students and to try their best to accommodate and care for each one on his or her own level.

Seeing how the actors would switch shoes mid-performance to take on someone else's character, I wondered why the same action should not be emulated in the classroom.

We must teach children to put themselves in their neighbor's shoes—to humble themselves to understand that we as human beings all possess the same emotions. In the play "Twilight: Los Angeles," the actors performing on stage carried out this poignant theme. As they (the actors) changed character they left their shoes off to the side of the stage. This poetic gesture acknowledges that we should not judge one another but rather put ourselves in the position of the other person, and learn to understand cultural difference rather than judge them.

The most important factor I learned is to "put myself in someone else's shoes." To become aware of my surroundings and to better understand how all children have many different experiences in life, and I must try to involve them in the curriculum.

One of the things that happened in the play that I thought was the most interesting to me was when the actors took their shoes off. At first I didn't realize why they were doing it. Then later in the play as all four kept putting each other's shoes on I realized what it meant. It meant that while they were playing other characters they were in other people's shoes, to show how it felt to be in other people's shoes.

The purpose of this play is to ignite conversations about race. It will force you to put yourself in "someone else's shoes" and make judgment calls you might not normally make without seeing someone discriminated against first hand.

It was also interesting how they showed the characters in the play literally taking off and putting on shoes. They were literally trying to put themselves in the place of someone else. I think that this idea can teach a message of respect for one another, and if you think about it, we are really not so different.

Smith was trying to become something she was not, by walking in other people's shoes, and this performance encouraged us to act and move further in our American journey, and get to "we"— the people.

(d) Deepening compassion evidenced by identification with a particular group of characters in the play. As I have explained in previous chapters, an "allegiance" in one's identity is constructed from a collection of related experiences. The following quotations demonstrate that students had analyzed their own social allegiances, and some had understood how these influences caused them to identify with particular groups portrayed in the play. This analysis helped them to discover their own unrecognized biases, which may have led them to perpetuate racism, sexism, and/or social class inequalities.

As I watched the performance along with the recorded live footage of the Rodney King beating and the riots, I too could feel the voice of the unheard. In some of the scenes they performed they made me feel really emotional. I wanted to cry in some of the scenes.

After seeing the performance I feel as if the whole semester tied into this performance in some way. Personally for me, since I am not considered a minority, I feel as if I have taken for granted the rights and privileges I am offered in everyday life.

We the audience are able to hear what the media otherwise discounted as not newsworthy. The importance of compassion is especially felt from Anna Deavere Smith's portrayal of a storeowner, Mrs. Soon Young Han. Mrs. Han represents the reality about the American dream.

In the "Twilight Los Angeles" performance, Twilight Bey says, "I see darkness as myself. I see the light as knowledge and the wisdom of the world and understanding of others, and in order to be a true human being, I can't forever dwell in darkness. I can't forever dwell in the idea of just identifying with people like me and understanding me and mine." It is up to me as a teacher of color to show my students the light.

What I saw as a revolution, others saw as Blacks destroying their own communities.

I never took notice of the seemingly small things that make being a White person a privilege in American society. With this in mind, our schools are in dire need of reform.

(e) Critical awareness in describing their future roles as teachers. When students become aware of how their allegiances perpetuate oppressive social constructs, they develop a critical consciousness that can help them to understand systems of domination and notions of justice. The next set of quotations illustrates this development, as students describe a newfound appreciation of their future role as teachers.

In the past when I've been asked why I want to be a teacher my response was very simple, because I like children and it's an easy job. After taking this course however, I came to the realization that my task as a teacher is going to require a tremendous amount of time, patience and effort. The reason being that my responsibility will not only require me to teach these children how to read, write and count, but also how to be open-minded and diversified individuals.

As teachers, we have the greatest responsibility resting on our shoulders: we are, for better or worse, molding our future society. In sum, seeing Twilight L.A. was not only a learning experience, but a captivating one as well. It opened my eyes to see that every day we are placed in groups or categories, starting as young as five, and in order to change this we have to start changing the institution of education. Thus, one hopes that with the integration of multiculturalism, as well as throwing out tracking, one can create an overall better learning system for children.

I believe that the most important thing you can realize before becoming a teacher is that entering a classroom with an open mind and heart will open doors for your students. This will also enhance your experience of becoming a successful teacher. It is also essential to understand that your students are not the only ones experiencing the learning process, but you as the teacher can learn a great deal from the students as well.

During this course I have learned there are ways and possibilities to change or improve the lives of children. As Anna Pennell (2006) expresses it, "I will not lose hope that change can and must be created" (p. 459).

This course allowed me to learn many things about our educational system and our society. There are still many inequalities floating around us, but I believe that if we continuously have teachers who are willing to put forth their effort into making a better educational system, then we can eventually have students who learn the values of love and equality. With these values, students will open their mind and heart and use them to love each other's differences and eliminate conformity.

Many of the readings that we have read and discussed in class, along with some of the videos we watched, help us to better understand how many types of inequalities are perpetuated through the education system.

As I reflect over all the issues we have discussed this semester I have come to self-actualize what I have to change to be a good teacher to my future students. I have to rid myself of any negative ideologies and truly understand who I am as a person before I can educate children on how to be a good person. Even though I know I have a long way to go, this class has helped me move a step forward towards gaining the knowledge I will need to educate children to the best of my ability.

As future educators, we must be aware and sensitive to every child's culture and traditions, and treat them with respect and validity. I realized that much of the misunderstanding that occurs between races, cultures, genders, abilities and social classes begins in the classroom.

Teachers unknowingly teach such things as racism, not by what they say or do, but more importantly by what they don't say and don't do.

(f) Empowerment to change social inequalities, starting in their own classrooms. As the passages quoted above illustrate, some of my students demonstrated a newly developed critical awareness when describing their roles as future teachers. However, these narratives revealed only a reflective stance, while other students showed a progression beyond social awareness into empowerment to create social change, starting in their own future classrooms. The quotations in the next group call for action in the interest of changing society, by teaching future students democratic values such as open-mindedness, desire to better one's community, understanding and acceptance of difference, and commitment to combating injustices and social stereotypes.

I realized that for our society to change somebody has to take the first step, which I plan on doing in my classroom. However my obligation as a teacher will be to ensure that children are taught different perspectives so that they themselves can choose their own path. This is at least as important as teaching them their basic academic subjects.

When I first entered this class, I would think about my future and how nice it would be to leave my neighborhood and move to a better one. Now I realize that I have the power to better the one I live in now. Unfortunately we live in an unjust world, especially when it comes to social classes. The richer the neighborhood, the more money paid in taxes, the more money for those specific schools. As a future teacher I know that this specific situation isn't going to change overnight, but now I know if I move away, I am allowing it to stay the same.

Just when I was becoming frustrated with school and questioning my reasons for returning to school at the age of thirty-two, I took this class and remembered why I wanted to teach in the first place. I want to make a difference in the lives of children, because unfortunately there are too many children who slip through the cracks of our society, unnoticed and neglected. Even if I am only able to reach out to one child who really needs guidance and someone to care about them, I will have done my job.

I believe in order to educate our students, it is our responsibility to teach them in detail that racism and stereotypes still exist today, and we are partially at fault because we can't see and accept people for who they are. We need to make them aware that these issues affect all of us in some way, and therefore we need to become better at understanding and accepting people. We need to work together as teachers to create a world of ideologies that recognizes these issues in our world today.

As a prospective teacher, it will be my job to eliminate these injustices and stereotypes within our society by teaching children to love and accept one another. Without love, there is just more room to discriminate.

There are certain events or moments in your life that touch you forever. I am taking education courses as a prerequisite to be able to work in public schools when I graduate with my speech pathology B.A. However, because of this course I am thinking of getting my master's in education. I overtallied into this class and for that I am very grateful to you. This has been my favorite class here at this college, and the one that has affected and taught me the most. This class makes you think on your own and makes

you want to change the world. Though I, by myself, in my own classroom cannot change the society we live in, if I can change the 30 students I have, it will be because this class taught me how.

The root of the problem is that we allowed socially constructed restraints of difference to divide us as a community.... We must learn from history so that terrible acts like this never happen again. If we enlighten our children to be empathic and respectful to one another, we then can change society's views on ethnicity, class, and race.

It is imperative that teachers empower students to become the best person they can be, regardless of the racial discrimination they may encounter in life, and one way they can begin to do this is to incorporate a diverse curriculum into the classroom.

There has to be a way to change the inequalities and racism that are imbedded in our system. It can start in the classroom; as future teachers we must incorporate into our hidden curriculum ways to change these stereotypes...of different groups based on their ethnicity and race.

We must change these injustices and inequalities, and this can start in the classroom. As educators we help form the future generations, and we must eliminate the problem at the core, through our education system. If we eliminate competition and the tracking system, and incorporate a well-rounded multicultural education, this will help us achieve the goals of an equilibrium society.

Summary of results. In this case study, the focused aesthetic encounters engendered a range of reactions. Some students were moved to a deeper level of critical reflection, some developed a sense of self-empowerment, and others achieved full social empowerment. All of the students in this study demonstrated that they had developed a genuine connection with the work of art, and that it had awoken a desire to create positive change, in their own lives and for the benefit of others. This represents a successful result for the critical aesthetic session.

Critical Aesthetic Pedagogy Sessions at the Borough of Manhattan Community College

The next case study I will present involves a significantly different population. While students at Queens College come from working-class to middle-class and mostly White backgrounds, the majority of students at Borough of Manhattan Community College (BMCC), in contrast, belong to relatively disadvantaged groups. Students in my teacher education classrooms at BMCC come from poor or working-class neighborhoods, and many are people of color and/or single parents with full-time jobs. I should also highlight that many of these students are immigrants or children of immigrants and are therefore English Language Learners.

As I explained in the previous chapter, our experiences of culture, language, and social class define the ways in which we express ourselves, create meaning, and understand the world. Some of these sociocultural and linguistic influences are apparent in the verbal styles of student writing quoted in the two case studies I have presented in this book. BMCC students and Queens College students come to my classrooms from widely different perspectives, and as their experiences and backgrounds differ, so do their voices. A fundamental benefit of Critical Aesthetic Pedagogy is that it can create a safe haven for students of all backgrounds to feel comfortable expressing their ideas and sharing their experiences. More importantly, this method employs these differences as the principal tool for curricular development.

The second case study I will present to demonstrate the efficacy of Critical Aesthetic Pedagogy involves two undergraduate Social Foundations of Education sections that I taught at the Borough of Manhattan Community College, City University of New York. Although this school differs considerably from the site of the first case study, the results indicate that Critical Aesthetic Pedagogy can function similarly in widely different settings, and this underscores the cross-cultural applicability of the critical aesthetic method. The founding principle of my approach lies in allowing students to use their prior experiences, *whatever they*

may be, to connect with an artwork on an emotional level and thus reunite with their body authority, and this is a process that can succeed with students from all backgrounds.

The Borough of Manhattan Community College (BMCC) is located in downtown Manhattan approximately two blocks from the site of the World Trade Center. As a matter of fact, this is the only college in the United States that lost a building during the attacks of September 11, 2001. BMCC serves 22,534 students living in the neighboring urban areas, and 1,547 of these students are enrolled in Teacher Education programs. Most of them are women who fit the overall self-reported college demographics of 32.9% Black, 38.3% Latinas/os, 14.1% White, 14.4% Asian or Pacific Islander, and 0.2% American Indian. 64.2% of the incoming students who responded to a survey reported living in families whose total annual income was under $25,000.

At the time of this second case study I had spent several years working with the Lincoln Center Institute's Aesthetic Education Program, and was less involved in the CUNY collaborative. I felt fully confident in my ability to develop Critical Aesthetic Pedagogy sessions drawing on the many artistic resources that New York City has to offer, and to devise effective lines of inquiry and curricula for the accompanying workshops. What follows is a description of the session that I developed for my two classes at BMCC, including the featured artworks, the focus of the session, the line of inquiry and discussion questions, and the workshop activities.

Setting the stage: Selecting the featured artworks

For this session of Critical Aesthetic Pedagogy I integrated the study of three self-portraits by Frida Kahlo: *Self-Portrait on the Borderline between Mexico and the United States* (1932), *With Cropped Hair* (1940), and *Diego in My Thoughts* (1943). Frida Kahlo's work is known for its strong, unmitigated expressions of pain and passion, as well as its intense and vibrant colors. Most of her work also demonstrates her pride in her Mexican and pre-

Columbian cultural traditions. Frida Kahlo suffered lifelong health problems resulting from a traffic accident in her teenage years. Nevertheless, she created close to 200 paintings, drawings, and sketches representing her life experiences, her physical and emotional pain, and her turbulent relationship with her husband, the painter Diego Rivera. Fifty-five of her paintings are self-portraits.

Developing focus: Course structure and selected readings

I developed the syllabus for this session around the issue of identity to examine the influence that social allegiances can have on the choices we make in life, and how these allegiances, if unanalyzed, can lead us to perpetuate systems of domination and oppression. The main purpose of this session was to develop my students' awareness of how their identities are shaped by their experiences, and how these influences can affect their future classroom practices. As in all critical aesthetic teaching sessions, the overarching goal was to foster or create a sense of self and social empowerment.

Assigned readings were selected from *Schooling in a Diverse America Society* (2010), edited by Yolanda Medina and H. Svi Shapiro. Students were expected to read the assigned articles before class, consider them in the light of their prior experiences and their future role as teachers, and come to class meetings prepared to talk about them, utilizing the featured artworks as a backdrop for discussions. After each session, students were expected to write journal entries discussing the elements described above.

Shaping the discussion: The line of inquiry

Line of inquiry. How can Frida Kahlo's self-portraits be used as a critical element in the understanding of identity? How can artworks of this kind play a role in the investigation of personal experiences and cultural influences? Can works of art that reveal the human condition become a source of personal and social empowerment?

Questions that drive the line of inquiry:

- What is identity?
- How does Frida Kahlo's identity affect her technique?
- How can personal experiences of race, gender, and social class affect a classroom community?
- How can the study of Kahlo's self-portraits help to prepare fair, unbiased, and caring teachers?
- How can artworks of this kind be used as a tool for teaching about democratic values such as valuing diversity, considering multiple interpretations, respecting difference, and embracing social tolerance?
- Can works of art such as Kahlo's self-portraits help teachers develop an appreciation of how cultural experiences shape values and teaching styles?
- What do the symbols and words in Frida Kahlo's paintings represent?
- Does the setting of each self-portrait impact the way viewers perceive the work of art?

Exploring experience: the workshop activities

After developing the line of inquiry and its driving questions, my next step was to design the classroom activities. I wanted to engage the students in a mixed-media, art-making project in which they would depict an important emotional experience of their own, comparable to the self-portraits by Frida Kahlo. The students' creations would serve as a focus for exploring the issues of identity and social allegiance that were at the heart of the course curriculum. I dedicated two entire class sessions of one hour and forty minutes each to the workshop activities, viewing the artworks by Frida Kahlo, and discussing of the contextual materials. For this Critical Aesthetic Pedagogy session I prepared eight activities for individual, paired, and group work (Activities 1–8), and a brief description of each will follow.

On the day of the first workshop session, I prepared the class-room for activities 1–7. The room was furnished with 6 long tables and 5 chairs for each table (30 seats in all). On each table I placed 10 pieces of white paper (32" x 20"), 10 pieces of tan construction paper (8.5" x 11"), 2 scissors, 2 bottles of glue, 10 paint brushes, 3 cups of water (for washing the paint brushes), 3 paper plates, and two large trays of tempera paints in the following colors: red, blue, yellow, black, and white. One student later described the room as she saw it for the first time:

> When we walked into the room there were six tables with five seats in each table. The tables were covered with brown paper and for each seat there were two white papers and two tan papers. And there were a few paint-brushes on each table with two painting palettes that consisted of basic colors such as black, white, blue, yellow, and red. I was excited about what was going to happen.

As students walked into the classroom and sat down in groups, I announced that they were about to embark on an art-making ex-ploration, and that, as usual, there would be no right or wrong an-swers in our class discussions. I explained that during this class session they would be asked to think about themselves in a non-judgmental way, write in their journals, and create their own works of art. Finally, I reminded them that there is no such thing as a perfect work of art, and therefore they should not expect per-fection of themselves or others in this activity.

I began our class discussion by asking the students what they knew about Frida Kahlo's art and her life story. They already had some knowledge of Kahlo as an artist, partly because we had visited the Museum of Modern Art (MoMA) as a class, and two of her pieces were among the artworks we had viewed. Some of the students had heard of her before our museum visit, and when I sparked the curiosity of the others, they began to research her on the spot using their smart phones.

As our workshop discussion got underway, students recalled the facts they had learned about the artist. They mentioned that Kahlo was Mexican, that she was unable to have children, and

that she was married to a famous painter who was known for being a communist and a womanizer. Some students also mentioned the movie about her life entitled *Frida* (2002), starring Salma Hayek. After students had shared their knowledge, I also shared what I knew about the artist and spoke in more detail about her life experiences, cultural influences, and artistic choices, such as the prominent use of symbols, words, and lyrics in her paintings. Students would later describe Kahlo and her self-portraits as follows:

> *Frida Kahlo became an artist after she got in a bus accident. After her serious injury, she used to look at herself in a mirror, and that's how she drew her first self-portrait. The accident became a huge turning point in her life. She found herself as an artist painting her reality and her life experiences.*

> *Studying Frida Kahlo and being able to see her actual paintings has taught me a lesson in art, and by reading about Frida, I learned that she had a rough background dealing with medical issues, a car accident, and a divorce. Her painting career started when she got into a car accident and was unable to move for three months. Most of the portraits she painted were of herself, and she states, "I paint myself because I am so often alone and because I am the subject I know best." She paints what she knows best and what her experiences have brought her.*

> *I am currently studying renowned painter Frida Kahlo. She suffered a life changing accident which crushed her dream of becoming a doctor; from this accident she became a painter. She paints her suffering and pain.*

> *In the aesthetic workshop, we saw the paintings of Frida Kahlo, and how she made many positive things through her pain.*

> *In the workshop we saw paintings by Frida Kahlo. My favorite painting was the one [in which] she had chopped up all her hair. [This painting] was also at the MoMA. Frida found out her husband had been cheating and she decided to cut her hair, since it was what made her husband fall in love with her in the first place. She put lyrics in her painting that indicated Diego's love and attraction to her because of her beautiful long hair. She cut her hair without hesitation. In my opinion, I believe that [caused]*

an impact in her life, and changed it. Cutting her hair "freed" her from all the lies and broken promises. She was "brand new."

Many of Frida Kahlo's paintings could be used in the classroom to identify traditions and diversity among students.

There are two painting by Frida Kahlo which I can use as a lesson [Self-Portrait on the Borderline between Mexico and the United States, and With Cropped Hair]. We can discuss the environment and women's roles in our society.

Many of her artworks could be used to bring in different subjects that could be discussed further, which [would] allow students to picture and understand the time period and open their eyes to new things to explore and wonder about.

After we had shared our knowledge about Frida Kahlo and before we began the workshop activities, I asked the students to recall our previous class discussions based on assigned readings by Maxine Greene (*Releasing the Imagination*), John Dewey (*Art as Experience*), bell hooks (*Teaching to Transgress*), and Medina (a narrative included in Chapter One of this book), among others. We reviewed the issues that these readings had raised, such as the importance of encouraging children to use their imagination; the role of the arts in developing imagination and critical awareness; the ways in which personal experiences define our identities and thus shape the values and beliefs that we carry with us into our classrooms; and the importance of continually working toward our own self-actualization, in order to become better teachers. These topics would resurface as recurring themes in my analysis of students' writing, as will be seen later in this chapter.

At this point I will include some of my students' comments about the study of assigned readings in the context of the critical aesthetic session, and how this learning process affected them:

I am glad I had a chance to read Engaged Pedagogy by bell hooks and The Issue of Identity by Medina, and participate in the aesthetic workshop. Thanks to both articles, I have learned that knowing who we are and understanding what our allegiances are is essential not only for real-

izing our dreams and being satisfied with our lives, but also essential to performing our job/tasks with dedication and passion.

When I think of a teacher, I always envision wholesome young ladies with ribbons in their hair or very old fragile grandma types holding on to their ruler sticks. Silly as it sounds, but all true. I thought of myself as too tainted, with a bad history. But after reading Medina's article and participating in the two day aesthetic workshops, I know now that the only way to be effective in my classroom and with my students is to embrace those experiences and be completely transparent.

With the workshops and the readings I thought about the good things and the things that I need to get better in my personality in order to be a better person and achieve my desires of being a different educator. I have learned to respect each person and accept each student the way they are. I have learned that I really want to change, that I really want to be a teacher and change the life of a lot of people.

During the past week or so, I have been processing the articles. I started to think about my life, my experiences, and whether they affected who I am today. I came up with some answers, but what helped me the most in establishing some of my allegiances was the aesthetic workshop.

I am and will be forever grateful for what I have learned throughout this semester [from] the articles and the trip to the museum. I am grateful for the opportunity to ponder and make any necessary changes in my life before I step into and successfully lead a classroom of my own. This experience has truly challenged me to become a more whole version of myself on many scales. It has challenged me to be stronger to my allegiances as a young mother, an intellectual, and a future educator.

I learned so much this year because of Medina and the readings we were introduced to. So to my friends who ask why I am going to miss this class, it is because I learned what kind of teacher I want to be.

Activity 1: Creating Your Own Colors. (In pairs, 10 minutes). I planned the first activity as an icebreaker to help students ease into the process of creating their own art, without embarrassment or judgment. I invited them to choose partners and began by explaining that I had purposely chosen paints in the three primary colors (red, blue, and yellow) as well as black and white. I asked

them to use the paper plates and brushes to play with mixing color combinations, but I did not tell them what colors to mix or the results they would discover, as the point was to let them experiment. Students helped each other to create secondary colors (orange, purple, and green), and tertiary colors (combining primary and secondary colors, and lightening them with white or darkening them with black).

The students truly enjoyed this art-making process. Some said that they had not painted since elementary school; some were in awe of the results they achieved by combining colors; and those who knew the basics of color mixing took on the role of mentors. When they had finished, they all shared their creations with other students seated at their own table and at the other tables around the room. In their journals, students described this activity as follows:

> *I had a wonderful time mixing the primary colors and making it my own by making different colors. I did not know that [mixing] certain colors can make a different color.*

> *I cannot remember as a child in nursery or primary school having the opportunity to do these things; I am grateful for the opportunity I had, better late than never.*

> *The inner child in me showed its light and began mixing colors and getting excited over painting a picture.*

Activity 2: Who Am I? (Individual work, 5 minutes). For this activity I began by asking students to recall the assigned reading of a narrative included in Chapter One of this book, in which I described the allegiances that have shaped my identity. They remembered that I had described myself as a Latina Salsera, a Dominican York, a feminist, a rebel, and a teacher educator. I wrote all of these allegiances on the blackboard, and then wrote the words "I am a" before each one, to create the following sentences: "I am a Latina Salsera; I am a Dominican York; I am a feminist; I am a rebel; I am a teacher educator." Finally, I asked the students to take out a piece of paper and write the words "I am

a" at the beginning of three lines, then to consider their own alle-
giances, and fill in the words to complete the sentences. I ex-
plained that this list would be used in another activity.

Activity 3: Why Am I Who I Am? (Individual work, 15 minutes).
For the third activity I told the students that I was going to read a
passage aloud and that I wanted them to listen very carefully. I
recommended that they close their eyes so they could truly absorb
the meaning of the instructions they would hear. I reassured them
that nobody would be looking at them, because they would all have
their eyes closed, and I said that they could put their heads down
on the table if they wished. I wanted them to pay close attention to
my words, which would describe a journal-writing exercise. I read
the following passage:

> Think about an event or experience in your life that affected you, an
> event that you believe truly changed you, so you knew that from that
> moment on in your life you were not the same. It could be a good or a bad
> experience. Describe how you felt; the emotions you remember having at
> the moment the experience entered your life. Try to remember the
> changes in your breath, and the tensions in your body. Try to recall your
> surroundings—where were you? Was it a room, a park, a street, a hospi-
> tal, a back yard? Look around at the place where you were, and remem-
> ber as many details as you can—the walls, the furniture, the pictures
> and colors—everything that you can recall about the moment in which
> that experience came into your life. When you are ready, go ahead and
> start writing.

After reading the passage, I informed the students that they would
not be sharing this journal entry, so they should feel comfortable
about including as many details as they felt necessary to describe
the moment completely.

Activity 4: Building Silhouettes. (In pairs, 10 minutes). I in-
structed the students to choose partners, and told them that they
would be working together to make silhouette cutouts representing
their own bodies. The active person in each pair would use their
partner as a model for their own silhouette cutout, posing the

model in the position their own body had held during the experience described in the journal-writing exercise of Activity 3. Using the tan piece of construction paper and scissors, the active member would then cut out a silhouette representing their own body at the moment of their meaningful experience. The pairs would then switch roles and repeat the activity, so that everyone would have a silhouette cutout representing their own body. I reminded the students that they did not have to share their powerful experience with their partner in order to complete this activity. Students moved around the room, using bags, chairs, tables, walls, and the floor as props for their poses.

Activity 5: Filling in the Background. (Individual work, 30 minutes). I instructed the students to glue their silhouette cutout onto a white piece of paper, taking into consideration the position they occupied in the scene (on the left or right, in the center, or at the front or back of the space). They were then asked to paint in the setting of the experience they had described in their journal entry. They were given 30 minutes to complete the details of the scene. I explained that they did not have to draw themselves, as their silhouette would represent them in the picture, and I invited them to go back and read their journal entries for guidance about the details of the setting.

Activity 6: The Power of Words and Symbols. (Individual work, 5 minutes). For this activity, students were asked to use their "I am a…" list from Activity 2. I instructed them to choose one of the allegiances from their list, find a symbol or word to represent it, and add this element to their painting. I also suggested that they add a sentence, a song lyric, or a verse from a poem that connected to their experience. Finally, I suggested that they give a title to their work of art.

Activity 7: Guided Noticing. (Whole class, 10 minutes). After the students had finished their paintings, I taped them to the wall at the front of the classroom. I then invited the class as a whole to get

up and look at all the works of art. I reminded the students that this activity was not about judging the art or guessing what their peers' experiences had been, but about finding interesting elements that had emerged in the artworks, and identifying commonalities and differences among them.

In one of the class sections, students noticed that the symbol of a cross stood out in several of the paintings, and they discussed the various meanings this symbol could represent (for example, loss, healthcare, Christianity, positive pregnancy test, etc.). Students in the other class section commented on the use of colors, such as red and black, to represent anger and sadness, or yellows and greens to suggest lightness and good spirits. They said that they could see deep meaning in the paintings, which reflected a range of emotions, lifestyles, personalities, and life processes. One student commented that engaging children in classroom activities of this kind could enable them to express their individuality, and thus help teachers to understand what is happening in their lives and what is important to them, which would make it easier for teachers to relate to their students.

Other thoughts about the art-making activity were expressed in students' journals, where they explored the impact of creating artwork based on their own experiences, and of sharing that part of themselves, through their artwork, with the rest of the class. It was clear that this process had drawn them closer to one another and had offered insights into the ways in which our experiences shape our identities and our lives.

> *Thinking about an event that changed our lives, evoking all the memories of that moment, the emotions and surroundings, was an intense experience. Transferring it to paper, playing with colors and symbols was another experience, a next level. For me, this workshop was like therapy. It was really fun, because we got to laugh and joke, but also intimate. In my group, as we laughed and played with colors, we spontaneously started talking about our paintings and sharing our experiences. It was a different experience than regular work in groups. I think that for the first time, I felt a connection with my classmates.*

Seeing everyone's paintings about important moments in their lives—good or bad—showed how one experience can affect one's major decisions in life.

By remembering one of the experiences that have changed my life, I go through the pain again, and [feel] how that experience changed my ideas and made me a better person.

As we saw in the aesthetic workshop, each of us has a different situation that shapes us and makes us stronger or weaker; the way we approach things is what makes us different.

Viewing Frida Kahlo's paintings. On the second day of the aesthetic workshop, before presenting the artworks by Frida Kahlo, I explained to the students why I had asked them to describe and depict a powerful personal experience in our art-making workshop activities. Frida Kahlo was known for making art out of her most intimate experiences and passions, and for expressing her personal and cultural allegiances in her paintings. I had wanted the students to explore how their own allegiances emerged in their artwork when they focused on depicting a powerful experience that had changed their lives. This activity was intended to help them understand that their allegiances are expressed in all of their undertakings, though they may not always be aware of how these influences affect their lives and their behavior. I gave the example that doctors' allegiances are reflected in their choice of specialty and the way they treat their patients, just as teachers' allegiances are expressed in their classrooms—in the way they teach, and the way they treat their students.

While viewing Frida Kahlo's self-portraits, students discussed the emotions she had portrayed and her choices of colors and settings. They related these artistic choices to the facts they knew about her life story and discussed and drew parallels with the choices they had made in their own artwork and in their lives. One student later wrote about the commonalities shared among women in the class:

I noticed that the females who shared their thoughts seemed to share a common allegiance while viewing and analyzing Frida Kahlo's paintings.

We could all identify with her pain. I believe this somehow meant that [we share an] allegiance as strong women, which goes hand-in-hand with compassion, and this is definitely necessary to be a good educator.

Activity 8: Contextual Materials and Summary. (Groups and whole class, 30 minutes). After we had viewed and discussed the three self-portraits by Frida Kahlo, I shared the contextual materials I had gathered about the artist with the class. In groups, students pored over books and websites about Kahlo's paintings, her life, and her cultural influences, while continuing to draw connections with their own experiences and allegiances, which they had expressed in their artwork. We finalized the session by "pulling back the curtains" on the entire process. We discussed the structure of the session, the line of inquiry and related discussion questions, and the workshop activities. The journal entries quoted below express students' overall reactions to this Critical Aesthetic Pedagogy session:

The aesthetic workshop helped me make connections between my past and who I am today. It allowed me to discover some of my allegiances, and justified what made me who I am. It also made me think that art is a powerful tool that not only allows us to express our feelings, but also to discover our identity.... Now as I know what shapes my personality and what makes me happy, I have a motivation to continue developing it. I know that there is a lot more that I have to learn about myself, and that there are many aspects of my personality that I want to work on. I wish to remain true to myself and assist others in recognizing that we are all unique, and that is what makes the world beautiful.

I truly believe that it should be a requirement for college students to take a class that [includes] esthetic workshops that focus on identity and the self, before they can choose a major.

This is an approach that I can identify with as a teaching tool in a classroom.... In this classroom, imagination and the embracing of oneself as a unique individual...and the ability to make empathic connections between the self and others, are key components in learning.

Throughout my years in school I never had a teacher that used artworks as a way of teaching. After this aesthetic workshop, I realize how your past can determine who you will become in the future.

Analysis of recurring themes in students' writing

In my analysis of students' journal writing, I looked for recurring themes that indicated an enhanced critical awareness, an understanding of how teacher identity affects classroom practices, a sense of empowerment to create personal changes, and a sense of empowerment to pursue social change. As with the first case study, I had not told my students what I would be looking for in their writing, for two reasons. First, although I was confident that my students would feel comfortable expressing their opinions in my classroom and in their journals, I knew that if I gave them a blueprint for what I hoped to find, they would make sure it appeared in their writing, and this would cloud the effects of my study. Second and most importantly, I wanted to see how my students made sense of the process of connecting the class readings, the aesthetic workshop, and the works of art to their own experiences, and how they shaped the new knowledge. In analyzing my students' journal entries for the semester, I found seven recurring themes that demonstrated new awareness in areas I had emphasized during this critical aesthetic session. I have included some of the illustrative student quotations in more than one category, because I feel that they demonstrate the development of critical awareness in multiple areas. The themes I identified are the following:

(a) Critical awareness in relating the course readings to the aesthetic activities
(b) Critical awareness in describing the value of using the arts as a pedagogical tool
(c) Critical awareness in describing the importance of encouraging children to use their imagination
(d) Critical awareness in describing the need to create positive changes in their own lives
(e) Recognition of the role of experience in shaping identity and the importance of self-knowledge in becoming a good

teacher
(f) Critical awareness in describing the teachers they want to become
(g) Empowerment to change the lives of children, and to redress social inequalities.

I will briefly discuss each of these themes, providing illustration and supporting evidence from my students' writing.

(a) Critical awareness in relating the course readings to the aesthetic activities. The first theme that I identified in my students' writing was a growing awareness of the critical aesthetic process in which they were engaged. In the passages I have selected to illustrate this theme, students draw connections between the assigned readings and the aesthetic encounters they have experienced (workshop activities; exposure to featured artworks) and describe how the combination of these influences has affected their outlook. They are in fact describing their own successful engagement in the critical aesthetic process. Quotations expressing this new awareness can be found on pages 92 and 93.

(b) Critical awareness in describing the value of using the arts as a pedagogical tool. The next essential connection that I tracked in my students' journals was awareness that the arts can be used as a powerful teaching tool in any classroom. This concept was unfamiliar to most of the students participating in these sessions, who had received little previous exposure to art education of any kind. While some journal entries on this subject faithfully echoed the conceptual framework presented in the course materials, the passages quoted below show that other students had internalized the critical aesthetic process, expressing its value from a personal perspective.

> *Every time Professor Medina brought art into the lesson plan everyone had something different to say because of what they had learned from previous experiences; it helped the class come together in discussions and also helped us learn about one another.*

I didn't have a teacher who used art as a way of teaching until I met professor Medina. Medina brings art into the classroom, [and this] helped me open my mind to so many things, such as different views and culture. It helped me realize how art helps people say how they feel without saying a word, but showing it in their work of art. I have seen how art can let people express themselves and open new ideas to everyone around it, and also bring people with different personal experiences together.

My visit to the MoMA was really interesting and it is something that I would like to do with my students.... I am sure that my newfound love for art will help me become a good teacher because I can feel, understand, and express it. Also, I can make every lesson and every subject much easier for my students through art.

I think that art can be used as a tool to help students find their way. Having students exposed to art and encouraging them to express their understanding and interpretation of a work of art can be an enlightening journey for the students as well as the teacher.

As a future teacher I have learned the importance of using art in my classroom so I can open a world of thinking, making, and creating for my students.

Looking at this particular painting and other art works reminded me of the importance of art in our lives. Art allows us to release our imaginations and gives us the opportunity to interpret it according to our own understanding. The beauty of art is that people can translate it differently. Art is more diverse than language because it gives everyone the ability to feel the work in their unique way. Allowing children to explore artwork will help them develop their imagination as well as critical thinking.

(c) *Critical awareness in describing the importance of encouraging children to use their imagination.* In the following journal passages, I found evidence that my students had understood how encouraging the imagination enables children to enjoy the learning process, perceive multiple perspectives, develop critical thinking skills, and engage issues of social justice. It is clear that they have drawn on their own educational experience, in and out of the classroom, in exploring the concepts and issues that were addressed during the critical aesthetic session.

Why do so many young people hate the thought of going to school? My personal belief is the quest for knowledge, which used to be one of imagination, exploration, and innovation, has been scaled down to nothing more than compartmentalization. There is no more room for children to be inquisitive, which they naturally are.

Without the exercise of imagination in students (or people in general), there is no questioning of how prudent an idea is, no exploration of how an idea can be expanded or amended, and certainly no critical lens focused on the self-cognition of the idea. That space where there is a lack of imagination is eventually filled by the students' resignation to follow the idea and feelings of another, leaving one's mind as a tabula rasa, a mind not yet affected by experiences or impressions.

In other words, when able to use and accept their experiences, our children will become better learners, for their imagination and experiences will provide them with the answer that there is no such thing as "normal."

Just like Maxine Greene said, education is not only in the classroom, it is in the imagination of the children, [and that is what] makes them who they are today; [if they are not] able to explore through their imagination, then education to them would just be boring.

A child's imagination should never be diminished, but encouraged and nurtured to do great things.

Every day that the education system allows such rote learning, a child's imagination dies with it.

Educators must learn how to tap into their students' imagination and encourage them to use it toward positive change. Encourage them to become active members of society, seeking change in a world that can be cruel and unjust.

(d) Critical awareness in describing the need to create positive changes in their own lives. The following passages demonstrate that students have understood the need to create positive changes in their own lives, in order to become teachers who will influence children's outlook in positive ways. They have realized the importance of continuing to develop their self-knowledge, not

only for their own benefit, but also for the sake of their future students.

What capacity of teaching can [I have] if the compartmentalizing of my being means that I leave that person behind once a class period commences? Not that my state of comfort or happiness are paramount here, but how can one function from a stance that causes discomfort in their person? As Thich Nhat Hanh is quoted by hooks: "...if the helper is unhappy, he or she cannot help many people."

In order for any educator to promote the wholeness of a student, they must understand that the process they are trying to instill must first come from within. As a future educator, this was an important element that I needed to realize, not just to teach students, but also to help them understand that every aspect of themselves will play a part in their learning process.

I think that establishing one's own identity and finding a purpose is a process. It is a continuous process that requires time, patience and re-analyzing our past experiences.

The importance of being a real person to children, and not just being an object to be feared, is critical in the approach to teaching. Teachers have to connect to their students in a holistic way and not in a hierarchical and authoritarian way.

I am glad I had a chance to read Engaged Pedagogy by bell hooks and The Issue of Identity by Medina, and participate in the aesthetic workshop. Thanks to both articles, I have learned that knowing who we are and understanding what our allegiances are is essential not only for realizing our dreams and being satisfied with our lives, but also essential to performing our job/tasks with dedication and passion.

I am grateful for the opportunity to ponder and make any necessary changes in my life before I step into and successfully lead a classroom of my own. This experience has truly challenged me to become a more whole version of myself on many scales. It has challenged me to be stronger to my allegiances as a young mother, an intellectual, and a future educator.

With the workshops and the readings I thought about the good things and the things that I need to get better in my personality in order to be a better person and achieve my desires of being a different educator.

Now as I know what shapes my personality and what makes me happy, I have a motivation to continue developing it. I know that there is a lot more that I have to learn about myself, and that there are many aspects of my personality that I want to work on. I wish to remain true to myself and assist others in recognizing that we are all unique, and that is what makes the world beautiful.

I truly believe that it should be a requirement for college students to take a class that [includes] esthetic workshops that focus on identity and the self, before they can choose a major.

(e) Recognition of the role of experience in shaping identity and the importance of self-knowledge in becoming a good teacher. The passages in this group indicate that students have explored and understood how their own process of personal development, through learning experiences in school and in life, will be linked with their future students' journey—not only as a model of good and bad approaches, but also as a crucial connection between students and their teacher. This concept represents a radical departure from the "banking concept" of education that many of them experienced as students, and they have embraced it with vigor and hope. They have come to appreciate the value of personal experience as a pedagogical tool, and even more importantly, their comments indicate that they plan to use this knowledge to empower their future students.

As a result of understanding my allegiances, I now know the kind of teacher I want to become. Born and raised in Guyana, I lived and attended school for more than half of my life there. I can truly say that I do not regret my experiences of the schooling I tolerated and the choices I made, but I wish some of the teaching methods could be different, as a result of the schooling I had in Guyana and some over here in America as well. I do not want my students to have the same experiences, but something better and different.

Essentially, our personal stories as teachers come into play in outreaching, and our allegiances to the things that make us who we are, as people, become a tool of pedagogy. Our main goal as educators in this sense is to utilize our allegiances in [such a way that] what we've learned of life, out-

side of textbooks and studies, becomes an enormous additive to the lesson administered.

I began searching through my life experiences which have brought me on the path I am now. All the choices I've made, good and bad, have made me into the person I am today. I never thought that those experiences would ever be useful in a classroom. Everything I have been through not only will be used, but will mold me into a better educator as well.

When I first thought of becoming a teacher, I felt that the reason was because of my good skills working with children. However, [in this class] I came to the understanding of my primary reason for becoming a teacher. For example, when I was seven years old I used to be a bully, until one day this other child stood up to me and fought back. He surprised me with his courage: I was in awe! When he beat me down, the children I used to pick on rushed to the scene so they could also jump me. Soon after that event, I came to the realization that I was the one getting bullied in school. After that event, I was bullied for seven continuous years. Even though there was physical pain from the bruises, it was not as painful as being lonely. Because I was lonely, I tried to fit in with other groups of children. It is because of this experience that I want to help children and teach them the value of respecting one another. It is because of this experience that I have become a very social person. The value of giving help, respect, and comfort to children is the reason why I want to become a teacher. I want to share my experiences and help others.

I know that the past values that I carry with me every day will catapult me into the field that I desire. "I am a compassionate soul," "I am dedicated to integrity," and "I am an advocate for justice." Those three main morals keep me motivated and my eyes on the big picture.

I have looked into the mirror and I have seen who I am, and every day I am loving who I am shaping to be. I am a Latina/Siciliana, a mother, a student, a singer, and a Christian. All of those elements have molded me to be an effective educator for myself and for my future students.

Determined, I came to the conclusion that when I become an educator I would not let the same things that happened to me affect the younger generations that I come into contact with.

I believe that when I become a teacher I will use my past experiences as a way of knowing what not to do. I will teach my students how to have a voice in what they learn.

I will never silence a student nor follow the rules just to receive a check. I am a mother, I am a teacher by heart, I am a role model, I am a listener, and I put others before me. All those characteristics and many more will empower my students.

(f) Critical awareness in describing the teachers they want to become. The narratives quoted in this group demonstrate that my students have begun reflecting on the kind of teachers they want to become, and the positive influence they hope to have on their future students' lives. They express their desire to empower children and to help them feel included in the class and in the learning process, by letting students' perspectives play a role in shaping the curriculum. They have understood that this will help their students learn to accept varying points of view expressed by people of different backgrounds. Finally, they make it clear that they want to become teachers who are perceived by their students as real human beings, who are still in the process of learning about the world and about themselves.

I want to be remembered as someone who has helped each of my students in a way to become better people, to achieve their dreams, to become responsible. I have learned that schools are not just about subjects, and my future responsibility as a teacher goes further than sharing facts, but also [includes] sharing and creating stories that help us in our future.

As a future educator I want my classroom to be a hub of free flowing ideas. And although I have yet to know or see how I will make a difference for our future, I know that I will, because I must. Our "at risk," in need, and underprivileged youth is in desperate need of change, and in need of the power that knowledge provides.

I know that my will to survive, to overcome obstacles in my life, will carry me in my classroom, and my students will feed off that energy.

I want to be the teacher that I never had growing up; I want to be a teacher that brings a fun way of learning into the classroom and also

shows that students have a voice in what they learn and what they take away from what I teach them. I would love to work in a school that involves teachers in discussions about the school curriculum. I want to be part of a school that puts students first before deciding to cut programs just because they can.

I know that most of my future students will be from different cultures. Even though they will feel like they are not part of this society, I want to make them feel part of my class, part of me and the other students; and the only way to do this is to take into consideration my students' backgrounds when I teach.

Sometimes we as teachers tend to judge the way people speak, or their personalities; however, as a future teacher I would like to work on myself and my children to break this pattern of judging people because of their culture, community, or family.

I want to be a democratic teacher. I will use all of my children's ideas and create lesson plans with them, and let them speak their minds as well. Everyone has different ways of learning, the same way we all have different DNA, and we all have different views and ways in which we interact with others.

I learned that as a teacher I will be in charge of engaging my students to think for themselves and create a relationship with others. As a teacher I will not give them my ideas, I will guide them to develop their own knowledge and perspectives about our world.

I also learned that it's not wrong for teachers to talk about their experiences with their students, [because] that way they can see you as a real human being who has been through [experiences] similar to [theirs], and they can feel closer to you and have more confidence in you. I plan to apply this method in the future to improve my way of teaching.

What is crucial in the dynamics of teacher and students is that the teacher has to relate to each child on an individual basis and not categorize them. For the relationship to work, the teacher has to be seen as a person by the students and not someone to be intimidated by. The students have to be seen as people too, with feelings, concerns, and having opinions and perspectives which may be different for that of the teacher. This opinion has to be respected.

Many teachers who are supposed to guide the spark that each student has, come into the classroom with what I call a "Vitamin E deficiency." What I mean by this is that they have little or no respect for the type of education that bell hooks refers to as "Engaged Pedagogy."

In order for me to empower as many students as I can, I will always travel with them on their journey of knowledge by allowing them to see that I too am on a journey of my own.

The teacher I want to become is someone who can inspire others to do what is right.... I want to be a teacher who listens to students. I want to learn from my students. [I want to be] a teacher [with whom] students wouldn't be afraid to share what is going on in their lives.... I believe students need someone to believe in them. They need to feel that they will be able to conquer anything they put their minds to.

(g) Empowerment to change the lives of children, and to redress social inequalities. This final group of passages demonstrates the ultimate fulfillment of the critical aesthetic process. It shows that students have embraced their own power to create democratic communities, and to change their education system, their country, and their world. They feel capable of standing up for their students, and teaching them to fight for their rights.

It is my goal to help young students become better than they were the day before.

I have confidence that I have what it takes to empower children and influence them to want to learn.

I am inspired to go out there and change the wrong things that are being done. I will spark minds and change the way people look at education today.

I am not afraid to speak my opinions, and I know that if I continue to fight for quality education, not only for my son but for all children, change must follow.

I am ready to embrace the education system and become a positive force affecting the lives of my future students, with my words echoing in their minds and hearts for years to come.

Change is possible; that's why we are in EDU 202, to learn how to help educate the world, one classroom at a time.

I will encourage my students to fight for their rights; I will help them fight for a change in our system so there will be more opportunities for children who deserve a better education. My most important goal is to help all students acquire the knowledge, attitudes, and skills to interact with people from diverse groups, in order to create a civic and moral community that works for all of us.

I am willing to stand up for my students and intervene on their behalf. I know such a gesture will go a long way in helping a teacher connect with his/her students.

I will fight for what I believe in, for what is fair and just, on behalf of the children in the education system. I know I have my work cut out for me, and I am more that OK with that.

The case of the resentful student

I am aware that Critical Aesthetic Pedagogy will not necessarily create a positive sense of empowerment for every student. No single work of art can challenge all viewers, because the power of an aesthetic experience lies in the relationship between the artwork and the perspective that the observer brings to the encounter. Likewise, no single work of art will empower all students to become agents of social change, because some may not respond with deepening compassion.

In most cases, students leave my critical aesthetic sessions with newfound critical awareness, as I have demonstrated with numerous examples in this chapter. Some also develop a sense of self and social empowerment—but others can respond with indifference or discomfort, and even resentment, or anger. I would like to discuss one case in particular, regarding a student in one of my Queens College sessions who came away feeling quite bitter about the critical aesthetic method in general and my course in particular. His final paper did not express his discontent, but a letter was attached to it that said the following:

I disagree with much of what I wrote in my final essay. I had to act like a lawyer and defend things I don't agree with personally. Why? Because all the essays we read to compare to Twilight: LA boiled down to Whites holding down the Black people.

Rich White men are not, in the vast majority, stepping over Blacks to get where they are. I have been set up so I would have to write a paper filled with half truths and exaggerations, holding high the Black people but putting down Whites.

While I enjoyed the class, it never prepared me to be a teacher. I am as unprepared as I was before the class. We spent half the time talking about society's racial problems, not school related problems. All that stuff is very interesting, but has nothing to do with my future career.

Although this letter takes issue with the fundamental focus and structure of the course, I believe that even in the case of this deeply resentful student, my critical aesthetic method achieved a measure of success. As I described in Chapter Two, Critical Aesthetic Pedagogy includes several elements that I consider crucial for the development of self and social empowerment, and one of these is the creation of classroom spaces in which students feel safe to share their opinions and personal experiences. As I also explained, at the beginning of the semester the students were given a consent form to sign, confirming their agreement to serve as participants in the research project that would derive from this course. The form clearly stated that all of the students would be able to participate in the critical aesthetic session regardless of their willingness to take part in my research, and that nonparticipation on their part would in no way affect either their final grade or their CUNY academic standing. It also stated that students would be free to withdraw from participation in the research project at any time.

With many of the students in my critical aesthetic sessions, I felt that I was "preaching to the choir," but this particular student was different. Over the course of the semester he shared some of his personal experiences and opposing opinions, while his overall disagreement with my political views was palpable in his silent,

yet respectful presence in my class. Nevertheless, although he clearly occupied a minority position in his attitude toward the course material, he still felt comfortable expressing his dissent in the letter that he attached to his final paper. To my understanding, the fact that this student presented me with this letter prior to the posting of his final grade proves that he felt safe in expressing his opinion, and that he clearly wanted his voice to be heard as a divergent element in my study. Otherwise he could simply have withdrawn from participating in my research, and my course, at any time.

The following quotations from his letter further illustrate that while he maintained a stance of dissention throughout, this student was fully engaged in the class, and in the process of pedagogical exploration:

> *I decided to write this to tell you my thoughts on this semester. First off, I would like to say you are a very good teacher, going to your class and seeing your passion and energy and intelligence really was a breath of fresh air. However, I had a few problems with the class.*

> *I really didn't care about your political beliefs. I have no interest in seeing you climb up on a soap box to preach. I'm very sorry the rich White man is in the White House but if you don't like it, go vote. Don't talk to us about standing up for Democracy, and that "we have a choice" and then give us a one sided mini-speech against the White House.*

Seen in the light of a critical aesthetic classroom, this expression of disagreement could even be taken as a suggestion of how I could become a better teacher—and in the spirit of my own pedagogical approach, I would be remiss to neglect the opportunity it presents for further self-evaluation. This, after all, is one of the primary tenets of my own method.

The next element that I consider relevant to this case concerns the presentation of multiple perspectives. My purpose in this regard is to help students appreciate that the different ways in which people understand the world are deeply connected to their individual experiences. In the case of this resentful student, my critical aesthetic method encouraged him to show tolerance for dif-

ference, and he exhibited respect for the other students to the extent that he did not initiate open conflict in class, despite his discomfort. Furthermore, by presenting me with a private letter expressing his own perspective, he implied that he expected I would show similar respect for him, and trusted I would honor the conditions of our contract.

Another essential aspect of my pedagogical approach lies in encouraging students to explore how their experiences shape their identity, and how they are marked by the larger culture in which they live. In the case of my resentful student, based on what he was willing to share in class, his identity incorporated several allegiances: he was a White, upper-class, suburban male, and none of these social groups were positively represented in the featured work of art (*Twilight: Los Angeles*). After careful consideration of his behavior, I concluded that this student, like all those in the class who developed a sense of self and social empowerment, was deeply affected by my critical aesthetic method. Even though he did not develop the type of social empowerment that I had intended, he was still empowered to take a stand for what he saw as an unfair representation of the groups that corresponded with his own personal allegiances.

Thus I feel confident in claiming that even in the case of this resentful student, Critical Aesthetic Pedagogy provided a dynamic and effective model for teaching appreciation of multiple perspectives, and fostering empowerment to act in the interest of positive social change. The Critical Aesthetic space that I created provided a safe milieu for all of my students to share their opinions and speak honestly about their experiences and their identities, even if one of them felt he had to do so in a private communication. In spite of his strong disagreement with the fundamental assumptions of the course, he understood and respected the multiple perspectives of his peers, as well as mine, and seemed to enjoy and benefit from participating in the critical aesthetic session. I have even wondered if his letter was simply a test of my integrity—to see if I would react by giving him a lower grade, thus proving that I do not practice what I preach (in fact, he earned a well-deserved

A). In any case, I believe that his action implied an increase in his own sense of social empowerment, even if only to the extent of feeling free to express his disagreement with a person in a position of authority.

Conclusions

As a result of my practical classroom experience and the focused research described in this chapter, I have concluded that Critical Aesthetic Pedagogy can indeed enhance the development of self and social empowerment, and thus promote the adoption of educational methods that advance social change. My method included three fundamental steps toward this goal. First, the presentation of multiple perspectives allowed my students to see that the ways in which people understand the world are deeply connected to individual experience, which shapes our identities and the choices we make in life—including the choice of becoming a teacher. This knowledge helped my students to develop tolerance for difference and respect for the multiple ways in which individuals create meaning. Second, the inclusion of the body as a mediator of experience in the aesthetic workshops helped students reconnect with their somatic sensibility, which is the first step in developing compassion for victims of social injustice. Third, exposing my students to carefully chosen works of art encouraged them to define and understand their identities in new ways, thus strengthening their new *critical* allegiance, or in other words, supporting the development of a critical voice that can be used to discuss issues of social justice.

I have demonstrated that in a successful session of Critical Aesthetic Pedagogy, students will respond in one of three ways: by developing a sense of critical awareness; progressing from there toward self-empowerment; or going on to achieve full social empowerment. Their responses will depend on the power of their aesthetic experience, and this in turn will be influenced by the life experiences they bring to their encounter with the work of art featured in the session. In my classes, the students who were best able to relate their repertoire of experiences to the critical aesthet-

ic process became empowered to create self and social change, while those who were slightly less affected by the artwork developed only critical awareness. On the other end of the spectrum, at least one student came away with a feeling of resentment for some of the fundamental assumptions of the course, but his willingness to share his reservations directly with me indicates that this also was a case of self and social empowerment.

In the final chapter I will present an overview of Critical Aesthetic Pedagogy and discuss some of the key issues related to its successful application at the local, state, and national levels. Having proven the efficacy of my method, I am ready to address the challenges that would arise in establishing its widespread use, and to encourage participation among the community of educators who can help to resolve these issues. As long as we can teach our students to see the world differently, we have the power to initiate positive change.

CHAPTER FOUR

Critical Aesthetic Pedagogy: Applications, Implications, and Complications

In this chapter I will begin by describing the most important elements of Critical Aesthetic Pedagogy and discussing how they contributed to the success of the two case studies presented in this book. I will also summarize the range of student responses to my method and address the limitations that I have encountered in its practice. I will then consider the changes that will be required to establish Critical Aesthetic Pedagogy in traditional educational settings and the challenges this may present, specifically for teacher education programs, art organizations, and K–12 public education. Finally, I will propose reforms that would allow Critical Aesthetic Pedagogy to grow and flourish in today's educational environment.

Key Elements of Critical Aesthetic Pedagogy

As I have demonstrated through my analysis of the case studies presented in Chapter Three, Critical Aesthetic Pedagogy can indeed enhance the development of self and social empowerment and thus encourage future teachers to adopt educational methods that will promote social change. There are five elements that I have found to be essential in this process:

- Inclusion of students' experiences
- Consideration of multiple perspectives
- Focus on the issue of identity
- Exposure to carefully chosen artworks
- Reliance on the body as a mediator of experience

Inclusion of students' experiences

For this method to succeed, it is of the utmost importance that teachers establish a classroom environment in which students feel accepted and safe to share their personal experiences. This can be achieved by setting clear guidelines for classroom behavior designed to ensure that the dignity of every person present is preserved, no matter how unusual their opinions may be or how uncomfortable the other students may feel. For the sessions presented in my first case study, I borrowed classroom guidelines from a graduate course that I took during my doctoral work and adapted them to fit my needs. These guidelines, quoted below, were read and discussed in class at the beginning of the semester and reread every time it seemed necessary:

As a member of this class, I agree to abide by the following recommendations:

1. To be an active participant
2. To listen carefully when others are speaking
3. To try new ideas
4. To agree to disagree
5. To recognize that there are no easy solutions to complex problems
6. To consider the personal meaning of the subject discussed
7. To support democratic classroom practices
8. To observe confidentiality

For the sessions presented in the second case study, I decided to let the students create their own classroom guidelines at the beginning of the semester, and subsequently revise or expand them every time we felt it necessary. By the end of the semester the guidelines read as follows:

As a member of this class, I agree to abide by the following recommendations:

1. Listen carefully
2. Respect others' opinions

3. Try new ideas
4. Be patient
5. Agree to disagree
6. Think before speaking
7. Be non-judgmental
8. Try new ideas
9. Give constructive criticism
10. Be an active participant
11. Keep confidentiality at all cost
12. Ask questions
13. Respect others' learning processes
14. Be subjective
15. Create a community of learners
16. Live in ambiguity

Two interesting developments emerged from allowing students to participate in the creation of the classroom guidelines. First, students came up with some points that were similar to the ones I had previously presented to my classes, but they also offered other points that were much more critical and insightful than the ones I usually suggested. Second, as we read and discussed the work of various authors throughout the semester, students kept adding new points that they found to be just as important as those adopted at the beginning of the semester, such as "to live in ambiguity," "to create a community of learners," "to respect others' learning processes," and "to be subjective."

In order to create a truly inclusive critical aesthetic environment, facilitators can initiate the collaborative design of classroom guidelines by asking students what they consider important, and then keep the resulting list open for revisions throughout the course sessions. Once this process of adopting and revisiting guidelines is firmly established, students begin to believe that their voices are considered important in this pedagogical approach, and they begin to participate more openly and take responsibility for their own and their peers' learning process.

Other techniques that can help students feel comfortable sharing their personal experiences include the use of small group dis-

cussions and regular in-class and at-home journal assignments, in which they can reflect on class activities and other course materials and state their opinions openly without feeling overwhelmed by the pressures of group discussions.

Consideration of multiple perspectives

The second key element of Critical Aesthetic Pedagogy lies in helping students to understand the importance of considering multiple perspectives. As a first step, students need to learn that the ways in which people interpret the world are deeply connected to their individual life experiences. This knowledge will help them to develop tolerance for difference and respect for the various ways in which individuals create meaning based on their social class, gender, language, and cultural background. Future teachers need to understand that they must remain respectfully aware of their students' backgrounds in order to affirm the validity of their individual voices.

By presenting multiple perspectives for consideration and discussion in our education courses, we can foster an environment in which expression of students' opinions becomes an integral part of the learning process. It is important for future teachers to grasp that if this process is not respected, the classroom environment they create will reinforce existing systems of oppression, because the only important voice will be that of the lone authority figure. Students will feel that their voices are not valued, and they will be unable to create meaning that is relevant to their lives and worldviews.

Understanding and respect for the value of multiple perspectives can evolve out of dialogue among students who embrace opposite views on the same topic, which will help all of the participants learn that there are many valid ways of looking at the same issue. Discussions of this kind should always be encouraged, as long as they adhere to the classroom guidelines created by and for the group to ensure that the dignity of every person will be respected and preserved.

As was seen in both of the case studies presented in Chapter Three, my students' reflective writing showed their new understanding of the need to create classroom environments in which differences are used constructively, and in which students function as whole human beings whose opinions are accepted, valued, and encouraged. Their writing also showed that they had learned how the arts could be used as a pedagogical tool to encourage the expression of students' varying perspectives.

Focus on the issue of identity

The third key element of Critical Aesthetic Pedagogy lies in helping students to recognize that identity is shaped by allegiances, and that these allegiances are shaped in turn by personal experiences related to social class, gender, language, and culture, among other influences. Once students understand this progression, they can begin to analyze their own identities and to consider how their allegiances will affect their classroom practices. This will lead them to appreciate the importance of continuing their own process of self-reflection in order to become better teachers.

To help students develop an understanding of this process, techniques such as the "*I am a...*" activity described in Chapter Three can be combined with critical aesthetic explorations of journaling assignments about powerful life experiences, as I did with my classes at BMCC. Activities of this kind can complement and enhance discussions of selected readings on teacher identity by authors such as bell hooks and Sonia Nieto.

In both of the case studies presented in Chapter Three, it is clear that students have begun a healing process of reflection and personal change, as evidenced by their frequent references to bell hooks' (1994) concept of "self-actualization" (p. 15) in their reflective writing. Students' narratives also demonstrate that they have gained a clearer understanding of how their life choices—including their choice to become teachers—have been affected by their previous experiences.

One powerful example of this process can be found in the narrative of a student in the second case study who shared his

memory of acting like a bully as a child, and then becoming the object of bullying at the hands of other children (Chapter 3, p. 51). After successfully completing the critical aesthetic process in my class, he came to understand that the reason he had decided to become a teacher was not simply because he enjoyed a good rapport with children, as he had previously thought. It was also because this particular childhood experience had taught him the importance of children learning to respect one another, and he wanted to pass this lesson on to his future students. The insights he gained and the methods he learned through participation in the Critical Aesthetic Pedagogy session gave him the tools he needed to become a better teacher.

Exposure to carefully chosen artworks

The fourth key element of a successful critical aesthetic session lies in exposing students to carefully chosen works of art that will engage and enhance their social conscience. The selected artwork should depict emotions and experiences that can easily be related to the core issues discussed in the reading assignments, which always remain at the heart of the course curriculum. It is also important to consider the artwork's potential as a focus of aesthetic workshop activities that will help to engage students as active participants in the critical aesthetic process. Finally, the featured artwork should lend itself to multiple interpretations, because this will make it easier for students to connect it to the course content and to their own life experiences.

In designing the critical aesthetic sessions for my Social Foundations of Education courses, I select artworks that offer political perspectives and/or explore essential elements of the human condition such as pain, celebration, jubilation, anger, and so forth. Artworks of this kind are easy to find in any modern art museum and most art galleries. After choosing the works of art, I research the artist's background and artistic choices, collecting contextual materials to present to the class. I then prepare aesthetic workshop activities that will enable the students to engage with the artwork through the critical aesthetic process.

In the first case study, I prepared my Social Foundations of Education course with a cultural studies approach. The reading assignments included topics from race theory, gender studies, ability studies, queer studies, issues of social class in education, and intercultural and multicultural education. As the featured artwork for the critical aesthetic sessions, I chose the theatrical production of *Twilight: Los Angeles* from the repertoire of the Lincoln Center Institute's Aesthetic Education Program, in which I was participating at the time. This work of art directly engaged the issue of racial tensions in American society and presented views on this topic from multiple perspectives.

In the second case study, I prepared the course content for the semester to focus on the philosophy of education as it applies to diversity issues. More specifically, the curriculum would include readings and discussions about democratic principles, multiple interpretations, aesthetics, and teacher identity. As the featured artwork for the critical aesthetic sessions, I chose several self-portraits by Frida Kahlo that had recently been put on exhibit at the Museum of Modern Art. These paintings are characterized by strong emotional content and cultural-specific symbolism, and they are uniquely suited for engaging issues related to identity and allegiance.

In both of the case studies presented in Chapter Three, controlled exposure to the selected artworks helped my students to define themselves in new ways. This process gave them a newly politicized identity, by revealing and validating their "allegiances" (Maalouf, 2000, p. 2) to various groups with which they had identified. The terms in which they described the artworks reflected the elements of their identities, in allegiance to groups defined by culture, gender, and marginalized or mainstream status.

My students' responses demonstrated that exposure to controlled aesthetic experiences can affect the expression of an individual's allegiance. During the course of the semester, they came to understand how their allegiances had engendered unrecognized biases that could reinforce inequalities in the classroom. They realized that they needed to maintain a constant process of *self-*

actualization in order to avoid perpetuating systems of oppression in their teaching methods.

Through this critical aesthetic process, my students were able to find their own critical voice and a firm standpoint from which to discuss the notions of justice that were reflected in the artwork and related class assignments.

Reliance on the body as a mediator of experience

The fifth key element of a successful critical aesthetic process is devising workshop activities that involve the body as a mediator of experience. These activities must help students connect with their *body authority*, which is the first step in developing compassion for victims of social injustice. As discussed in Chapter Two, *body authority* is the visceral feeling that helps us distinguish what is fair from what is unfair. Disconnection from this vital inner resource leaves us feeling insecure and doubtful of our capacity to make decisions, so we are more likely to let others decide for us. When we grow accustomed to letting others determine what "justice" means, we begin to assume that changing the status quo is beyond our power, and we become unable to see ourselves as agents of change.

Reconnection with our *body authority* affirms our capacity to make our own decisions, and to see ourselves as people who can make a difference in the world. We are no longer reduced to merely feeling pity for those afflicted by injustice, because we feel empowered to help them. Examples of this process can be found in both of my case studies, where analysis of students' writing revealed recurring themes of empowerment to redress social inequalities.

The aesthetic workshops should include one contemplative activity that prompts recollection of a meaningful personal experience, and the other activities can evolve around this central focus. They can involve physical processes that require students to interact throughout the classroom space and to create interpretive artwork of their own. In my first case study, students were asked to journal about an event they had witnessed or experienced at school

in which they or someone they knew had suffered some form of discrimination. The rest of the activities for that day (moving tableaux and monologues) were designed to help them explore these personal experiences through role-play and performance, in the style of the featured artwork. In the second case study, students were asked to write about an event or experience in their lives that had truly changed them. The other workshop activities for the session were geared toward collaboratively creating artworks out of the written experiences.

These activities reconnect students to the emotions they felt at the moment when a powerful experience entered their lives, and this helps them understand and connect with key elements of the artwork being studied, as well as the artist's creative process. Maxine Greene (2001) refers to this as "uncoupling" (p. 69), or using our imagination and our own personal history to help us *feel* what the artist means, rather than simply seeing or hearing it. An encounter of this kind helps us reconnect to our body authority.

At the beginning of the courses described in this book, typical student responses to examples of social injustice were, *"Yes, it's terrible, but what can we do?"* or *"That's just the way things are,"* or *"In a perfect world things could be different, but this isn't Utopia."* However, by the end of the semester, my students were writing: *"I realized that for our society to change somebody has to take the first step, which I plan on doing in my classroom"; "I have confidence that I have what it takes to empower children and influence them to want to learn";* and *"I will fight for what I believe in, for what is fair and just on behalf of the children in the education system."* By participating in the critical aesthetic process, my students had successfully connected with their power to create social change.

The Range of Student Responses

In both of the case studies presented in this book, students responded to their encounters with the featured artworks in one of three ways: by moving toward critical reflection, self-empowerment, or social empowerment. Their responses depended on the power of their "aesthetic moment" of communion with the

work of art, and the degree to which it affected them individually, in the light of their background and life experiences.

To return to Susan Stinson's (1985) description of the three dimensions of aesthetic experience, I can say that all of the students involved in both case studies moved beyond the first dimension, in which the observer remains emotionally detached because the artwork bears no connection to his/her previous experience. In both studies, all of the students were able to connect their own previous experiences to the featured work of art, and this gave it relevance in their lives.

Students who were only moderately affected by the artwork developed their powers of self-actualization but did not achieve social empowerment. This group reached Stinson's second level of aesthetic experience, which releases the imagination and helps us to envision a path towards a better, fuller, and more meaningful life. Some students described the aesthetic awakening they experienced in my course as a life-changing moment that gave them the strength and security to create positive change in their lives.
The students who were best able to relate their repertoire of experiences to the featured artwork achieved a new sense of social empowerment, and thus reached Stinson's (1985) third level of aesthetic experience, which she describes as emphasizing "the relationship of the observer/participant to the world," where "the aesthetic object is the lens through which we see/make sense of the reality of being a person in the world" (p. 78).

Addressing the Limitations of Critical Aesthetic Pedagogy

One important lesson that I have learned from my many experiences with Critical Aesthetic Pedagogy in action is that including powerful aesthetic moments in course curricula will not necessarily develop the desired positive outcome of empowering every student to create social change. I have had to realize that the sensitivities I want my students to develop are the ones that I myself have found important, based on my own notions of equality

and social justice, which in turn derive from my experiences, my allegiances, and my personal identity. As I have demonstrated using the case of the resentful student described in Chapter Three, a powerful aesthetic moment may engender a negative reaction, and even encourage a destructive use of imagination. I am reminded of Maxine Greene's speeches at the LCI after the September 11 attacks. On one occasion, she spoke of wishing to rewrite everything she had ever written about the imagination, to include consideration of the destructive ways in which it can be used.

It is clear that we cannot expect all students to react the same way when exposed to aesthetic experiences in the context of a critical aesthetic session. It has been my experience that the majority of students will develop a progressive perspective on social justice, but we must always be prepared to encounter the opposite reaction in students who do not find any connection with the artwork, the course materials, and the method itself. I have learned that in order to encourage the development of self and social empowerment in my students, the emphasis in course design should be not only on finding the perfectly evocative artwork and devising embodied classroom activities, but also on developing course content that is infused with moral concerns.

Social Foundations of Education is a cross-disciplinary field that enables the study of education utilizing one or more of the liberal arts disciplines such as philosophy, history, politics, sociology, or anthropology. Courses may address a range of issues related to gender, race, social class, cultural studies, ability studies, and queer theory, as well as international, intercultural, and multicultural education. They can be taught with different emphasis depending on the professor's interests and academic background, but whatever the chosen focus, these courses always engage issues of discrimination and privilege, fairness, oppression, justice, and equity—and Critical Aesthetic Pedagogy is eminently suited to this purpose.

Whenever I change the focus of study for my Social Foundations of Education courses, I begin by delineating the social issues

that will be at the heart of our inquiry, and the moral concerns related to their impact on people's lives. I then search for works of art to complement the subject matter that students will be asked to engage, and finally I develop the line of inquiry and aesthetic activities described in Chapter Three above. Through the critical aesthetic process, students will draw connections between their own experiences related to social justice and the suffering others endure due to common sources of oppression. When students truly appreciate the impact that the issues they are studying in class can have on real people's lives, they are more likely to become actively engaged in promoting the cause of social justice.

Challenges and Implications for Schooling

It goes without saying that the practice of Critical Aesthetic Pedagogy will confront numerous challenges and hold serious implications for our current educational system. To begin this section, I will address the issue of acquiring support to implement Critical Aesthetic Pedagogy in universities, schools, and organizations, and I will describe the most important elements required for successful training in this field.

Since vibrant arts departments are indispensable partners in the application of Critical Aesthetic Pedagogy, I will also discuss the impact of current national education reforms such as No Child Left Behind (NCLB) on the maintenance of quality art programs in our K–12 schools. I will then focus my lens on the local level in order to demonstrate the limited value accorded to arts programs by the New York City public school system in the past few decades. I will conclude by describing the changes needed to enable the implementation of Critical Aesthetic Pedagogy at the national and local levels.

Acquiring support for Critical Aesthetic Pedagogy

Interest in progressive pedagogies will always be initiated by concerned educators who submit proposals to their peers for the im-

plementation of new or revised curricula. Once interest has been sparked, support must be acquired from institutional administration. One of the most difficult tasks in the introduction of any new arts-driven program is convincing administrators of the importance of this approach. If proposals of this kind are to have a chance of success, administrators must be made to see the value of the arts as an indispensable part of the education of all children. They will then be more likely to invest money in utilizing artistic venues available in the community and to allow educators to spend time training for a curricular approach that is not sufficiently appreciated in today's educational environment. Interested educators must advance strong arguments in favor of the idea that an arts-driven curriculum such as Critical Aesthetic Pedagogy provides can be implemented in all subject areas, and will enhance qualities in students that strengthen their academic performance, such as critical thinking, creativity, self-discipline, team work, problem solving, and the ability to transfer knowledge to unrehearsed situations.

Training critical aesthetic practitioners

Once support is in place to incorporate Critical Aesthetic Pedagogy methods into an institution's curricula, training seminars must be prepared to familiarize educators with the critical aesthetic process. Faculty members should be strong believers in alternative teaching approaches that encourage experiential learning and that avoid the "banking concept" of education. These seminars should consider four key factors.

First, the seminars should include an introduction to the basics of aesthetic education and critical pedagogy as alternative teaching methods. To introduce the aesthetic approach, presenters can borrow from the LCI workshop model described in Chapter Three. Readings and discussions should consider but not be restricted to the dimensions of aesthetic experience, and the importance of imagination and emotional uncoupling as potential enablers of social empowerment. For seminar units on critical pedagogy, readings and discussions should focus on issues of identity and allegiance;

dynamics related to oppression and privilege; methods for creating a safe environment in which students can find their voices; and the importance of multiple interpretations in developing critical consciousness.

Second, in discussing the value of critical pedagogy for developing students' critical awareness, consideration must be given to its limitations in this regard. Chief among these is the fact that it ignores the importance of the body as a mediator of experience, and thus perpetuates the body-mind split. Participants should be made aware that we teach the way we learn, and this may be one reason why the body-mind split remains entrenched in our K–12 and college classrooms. Educators must be trained to consciously avoid approaches that reinforce oppressive models and to employ somatic methods that incorporate the body and its language into their daily teaching practices.

Third, educators should be exposed to participatory encounters with carefully selected works of art. The activities designed for this purpose must involve the body as a mediator of experience and employ its language to explore the artworks. Encounters of this kind have an extraordinary capacity to release the imagination and stimulate self and social empowerment, because they engage us at the level of our personal experience. This reconnects us to our *body authority*, which is the source of our power to create and recreate the world in which we live.

Fourth, interested educators must learn how Critical Aesthetic Pedagogy can fit into their curricula, and how they can model the critical aesthetic process in their pedagogical practices. Educators need to see the connections between the concepts embodied in Critical Aesthetic Pedagogy and the worlds their students inhabit, so that they can implement these practices effectively in their classrooms.

Challenges at the national level—"No Child Left Behind"

We are living in an era of rigorous academic standards and strict

accountability. Teachers are expected to demonstrate their students' progress in ways that the public can understand—using statistics, test scores, ranks, and percentiles. The No Child Left Behind Act approved by Congress in 2001 mandated that all public school students must test at levels identified as "proficient" according to state-defined standards by the end of 2014. Each state is responsible for establishing benchmarks by which schools that receive Title I funds (federal monies granted to economically disadvantaged schools) can meet the requirements for their Adequate Yearly Progress (AYP). Each state must then measure every public school student's progress in grades 3–8 using a standardized test in English Language Arts and Mathematics, and provide yearly reports on each student's performance as "basic," "proficient," or "advanced." To make matters worse, there is a clause in the law stating that if schools do not meet their Adequate Yearly Progress (AYP) requirements by 2014, they will face severe penalties, such as being closed down and reopened as charter schools, having school staff replaced, and/or being turned over for management by a state or private company with a demonstrated record of effectiveness.

Education Secretary Arne Duncan, in his March 2011 testimony before the U.S. Congress, stated that by "next year the number of schools not meeting their [AYP] goals under NCLB could double to over 80 percent" (U.S. Department of Education, 2011). He was subsequently criticized by his supporters for inflating the numbers, but they all nonetheless agreed that the situation was dire. To address this problem Secretary Duncan, with the support of President Obama, proposed a federal program that will grant waivers to states that are failing to meet Adequate Yearly Progress (AYP) standards. This waiver will allow failing states to keep their schools open, so children will not lose their schools, and teachers and school administrators will not lose their jobs.

The disadvantage of this program it that waivers will only be given to states that accept the current administration's vision of "reform," which now includes adoption of further one-size-fits-all standardized curricula and tests, expansion of the number of char-

ter schools in each state, and use of students' test scores to assess teacher and school quality. Under these conditions, public school teachers and administrators have been forced to eliminate all curricular activities that are not directly related to preparing for and passing the standardized tests in English Language Arts and Mathematics.

Given the restrictions of this environment, arts programs have little room to grow in the era of No Child Left Behind—with or without the waivers. Teachers are forced to "teach to the test," drill for rote learning, and train children to "bank" the information received in class. The students then regurgitate what they have learned on the standardized tests, and their performance determines whether schools will remain open and teachers will be allowed to continue teaching. As Eric Liu & Scott Noppe-Brandon (2009) aptly put it, "too many public schools focus on the measurable to the exclusion of the possible. As a result, too many students end up better prepared for taking tests than for being skillful learners in the world beyond school" (p. 30).

Even when schools are privileged to offer arts education programs to their students, these programs mirror a conservative, prescriptive, formulaic curriculum that is disconnected from current realities and artistic practices alike. The work of today's contemporary artists, as it is seen on the streets or in art galleries, museums, and theaters, challenges and resists structures of oppression such as these. To the dismay of these artists, when they walk into our public schools to work in partnership with educators and art teachers, they find inflexible lessons, outdated pedagogies, and unexamined works of art that are used only as examples with which to process rote-learned information.

Critical Aesthetic Pedagogy is antithetical to standardized, ready-to-use art curricula. Because our social world changes so rapidly nowadays, a one-size-fits-all curriculum is bound to be outdated before it is even implemented. Critical aesthetic educators must commit to a pedagogy that is flexible and ever changing, and that allows students to pause and be present, to ponder and challenge the realities presented in each work of art. Critical aes-

thetic educators need to be able to collaborate with other teachers—as well as local artists, museums, and theaters—to develop a community of practitioners that will support the widespread implementation of Critical Aesthetic Pedagogy and allow it to grow roots and thrive.

Challenges at the local level—the case of New York City

The likelihood of the arts playing an important role in a child's education is ironically slim in New York City, the artistic capital of the world. New York City, like all the other urban centers in the country, has been negatively affected by the shortcomings of the No Child Left Behind Act, with its emphasis on standardized testing in Mathematics and English Language Arts. In New York City, the results of these tests account for 85% of the Annual Yearly Progress (AYP) requirements. Unfortunately, the essential human capacities for imagination, compassion, and social empowerment are not measured by the NCLB assessment system.

Exacerbating this situation, access to arts education has been on the decline since New York City's fiscal crisis of the 1970s, and funding for arts-related programs in the city's public schools was essentially eliminated even before NCLB was passed. Conditions improved slightly under Mayor Rudolph Giuliani's administration in the 1990s, only to worsen again in the past few years. A bit of history will help to clarify the situation.

In 1997, Mayor Giuliani created Project ARTS (Art Restoration Throughout the Schools) with the assistance of the New York City Department of Education. This program was designed to restore arts education to all New York City public schools over a three-year period, with one-third of all schools joining the program each year. Seventy-five million dollars were allocated as a funding line to support the program. This funding line was to be used solely for arts education purposes, and it was appropriately utilized to hire certified art teachers, purchase art supplies and musical instru-

ments, and create partnerships with artistic organizations in the city.

In 2007 Mayor Michael Bloomberg launched a program called ArtsCount as a more fiscally flexible replacement for Project ARTS. With this program in place, principals are no longer required to spend allocated moneys on art education. In essence, the funding line was redefined as a resource that *should* be used for arts education, but that can be allocated by principals based on their own determination of where the money is most needed. As a result, the amount of money available for the purchase of art supplies and musical instruments, and for establishing partnerships with artistic organizations, has been drastically reduced. According to the Center for Arts Education's Research and Policy Briefing (Israel & Kessler, 2011), since the inception of ArtsCount in 2007,

> Funds to hire arts and cultural organizations to provide arts education services declined 36%, funds for art supplies, musical instruments and equipment declined almost 80%.... schools now spend, on average, two dollars on arts supplies and equipment per student per year. (p. 1)

This report also found that funds for arts teacher salaries had increased by 7%, but that the total number of newly hired arts teachers had remained almost the same as it was before the ArtsCount initiative, even though hundreds of new schools had been created since that time. To make matters worse, the 2012 New York City budget proposes to eliminate over 6,000 teachers from the system, and of those, 350 or more (15% of the total) will be arts teachers.[1] The sheer size of these cuts may push us back to the same level of funding for the arts that New York City received during the fiscal crisis of the 1970s, long before the introduction of Project ARTS. In a city that serves over 1,700 public schools with an average of 1,000 students per school, the monies allocated for arts education are now spread very thin.

Exposing students to the arts can be quite an expensive proposition. Luckily for the children of New York City, the city's artistic and cultural institutions recognize the importance of arts education and the negative effects of restrictions imposed by low per-

pupil expenditures in the public school system—$10,297 as the national average (National Center for Education Statistics, 2008)—as well as by wide funding gaps between urban and suburban schools. Whenever possible, cultural and artistic organizations shoulder a large portion of the financial responsibility for promoting arts education in the New York City public schools. However, some urban districts that educate large numbers of poor minority children cannot count on the support of local artistic and cultural institutions, and thus have even fewer opportunities to expose their students to the arts. This renders it almost impossible for them to incorporate methods such as Critical Aesthetic Pedagogy into their curricula.

Quality arts-driven programs such as Critical Aesthetic Pedagogy can provide are indispensable in the schooling of urban children. Through this method, children can learn to imagine new possibilities and to "look at things as if they could be otherwise" (Greene, 1995, p. 19). The critical aesthetic process can enable students to broaden their perspectives, to see beyond what is taken for granted, and to envision a better world. Administrators need to understand that there is no contradiction between accountability and imagination, which is the most basic and fundamental element in learning. They need to appreciate that quality arts-based methods such as Critical Aesthetic Pedagogy can engage the most disengaged students, make learning relevant and fun, enhance academic performance, reduce dropout rates, help students develop more positive attitudes toward school, raise attendance, and increase the possibility of students graduating from high school and going on to college—all benefits that stem from and depend upon students' sense of self and social empowerment.

If we prevent underprivileged children from developing these capacities, we close the door to a brighter future for them and for our country. As Maxine Greene (1995) has argued, "Too rarely do we have poor children in mind when we think of the way imagination enlarges experience. And what can be more important for us

than helping those called at risk overcome their powerlessness?" (p. 36).

Critical Aesthetic Pedagogy—The Way Forward

Before Critical Aesthetic Pedagogy can establish roots in our schools, colleges, and artistic and cultural organizations, educational leaders at all levels must take a long, hard look at current required learning standards and traditional assessment tools. Existing standards must be amended to allow educators greater flexibility in developing curricula, and better criteria must be devised for measuring student learning. This will allow teachers to abandon "banking" models of education and to experiment with alternative methods such as Critical Aesthetic Pedagogy, which use the arts to help students understand the world, their roles within it, and their capacity to change it for the better.

At the local level, we must hold administrators accountable for spending money allocated to the arts *on the arts*. A dedicated funding line for arts programs will ensure that all children receive the arts-based education to which they are entitled, and which they so desperately need. Schools will again be able to draw on these funds to create partnerships with local cultural organizations, which can offer valuable help in updating obsolete methods of incorporating the arts into school curricula.

At the state level, each state must create a more balanced accountability system that can track a variety of different indicators of what makes a "good school." These new standards must include arts education as an important element of the accountability system. As a matter of more general concern, states must also commit to providing adequate and equitable funding systems for their public schools. As things stand today, public schools in urban neighborhoods receive much smaller annual per-pupil allowances than those in suburbs and other more privileged areas. The year-by-year perpetuation of this disparity demonstrates our politicians' inadequate concern for the education of our urban youth, and it

seems increasingly unlikely that they will voluntarily pursue the establishment of programs such as Critical Aesthetic Pedagogy, which could teach students to question the inequalities and injustices of the existing system.

At the national level, we must take a long, hard look at No Child Left Behind. If we cannot eliminate it entirely (which would be my preference), we must at least amend it to allow states and districts to adopt more appropriate criteria for measuring their Adequate Yearly Progress (AYP) requirements. As it now stands, the NCLB waiver system for non-performing schools mandates burdensome additional testing and stricter standards of accountability, and thus reduces teachers' freedom to help students explore and understand their world through the arts.

The challenge that promoters of Critical Aesthetic Pedagogy will face when approaching education administrators for support is twofold. First, the dissemination of Critical Aesthetic Pedagogy hinges on approval of dedicated funding for arts education, and second, the application of this methodology will empower students to question the status quo, which is a chief fear of many of those in power. Individuals educated through critical aesthetic methods are more likely to challenge existing power structures because they will be able to imagine how the system can be changed to benefit the socially disadvantaged. If students feel empowered in this way, they will develop a sense of entitlement that will allow them to take a stand when necessary in the name of social justice.

As I have seen in my critical aesthetic classrooms, when teachers feel socially empowered, they commit to teaching in empowering ways. Their students in turn will grow up with a sense of social entitlement, empowered to continue the process of positive change. This chain of empowerment is what I want to establish through Critical Aesthetic Pedagogy. Again, to rephrase a quotation from Tupac Shakur in the film *Resurrection* (Lazin, 2003)—I may not be the one who changes the world, but I want to spark the minds of those who will.

Note

1 Information released by the New York City Department of Education on February 27, 2011.

EPILOGUE

This book has been almost seven years in the making, and it has been a labor of much love. It began as my doctoral dissertation, which I started writing in 2004 under the mentorship of Svi Shapiro at the University of North Carolina at Greensboro, and which I successfully defended in 2006. Since then I have published and presented pieces of it to enthusiastic reception, but in my struggles to secure institutional support for my methods in the currently hostile educational climate, I had begun to lose hope that my work would ever reach a wider audience. Imagine my joy when a book proposal submitted to Peter Lang at the urging of my dear friend and conference buddy Eric Sheffield resulted in a new lease on life for my work, and for the method I have applied and promoted over the course of more than a decade.

Revising and updating this material has been a rejuvenating experience that has reinvigorated my passionate belief in the arts as a powerful tool for creating social change. It also offered the opportunity for additional classroom research that defined an amazing semester with a group of students who were extremely supportive and enthusiastic. This project has reconnected me to my love of teaching and to my search for alternative forms of education that expand the lives of everyone involved, students and teachers alike. Not that I had lost my drive, but I had come to take for granted the things I already understood, and I was beginning to lose my connection to the constant process of *self actualization* that keeps us from being *sunk in the everydayness of life*. I can only hope that after reading this book, others will feel as I do and will dare to embark on the road of self and social empowerment through the practice of Critical Aesthetic Pedagogy.

I truly believe that Critical Aesthetic Pedagogy can change the world we live in, not just the ways in which we see it. This method can encourage educators to create inclusive, egalitarian, multicultural classrooms, and it can propel energized students forward into

the real world, seeing it with new eyes, *as if it could be otherwise.* My dream is to create a community of educators who will commit to using the arts as a way of awakening their students' belief in the possibility of positive change.

The one fear I have is that on reading my closing arguments in Chapter Four, some may feel that my conclusions about the outlook for Critical Aesthetic Pedagogy in our current educational environment seem somewhat bleak. Therefore I want to emphasize that I trust this method is well worth fighting for, because I have witnessed powerful changes in my own students' consciousness as they exit my Critical Aesthetic classrooms. I have seen students who demonstrated little engagement in the course subject matter blossom into deeply engaged critics of social issues, after being exposed to guided encounters with works of art that connect to their lived experiences. These students then dedicate their energies to addressing social issues related to the suffering of marginalized children, and they become newly empowered individuals with a strong desire to change the lives of the students they will teach.

About the cover

The lovely girl pictured on the cover of this book is Gabriela Taveras, who at the time of this writing is five years old, and an eager member of the kindergarten class of 2012. Gabriela is the daughter of Stephanie Gonzalez, one of the BMCC students whose narratives I have included in this book. Gabriela, like many children in New York City, attends an elementary school that is in the "restructuring stage" under the No Child Left Behind Act. Art is her favorite subject, but of course it was one of the first casualties of the NCLB accountability system and the New York City budget cuts that I discussed in Chapter Four.

Stephanie gave birth to Gabriela when she was 17 years old. Although her family supported her desire to finish high school, the responsibility of raising a child came first, so her dream of a college degree was put on hold. When little Gabriela started school, Stephanie decided to resume her own education and fulfill her dream. She is currently on the Dean's List at BMCC, majoring in

Childhood Education, and she will graduate with an associate's degree in June 2012. She will then transition to a four-year CUNY school to complete her bachelor's degree and become a New York State certified teacher. My proud delight in stories like Stephanie's and Gabriela's is one of the chief reasons why I teach at BMCC, the largest associate's degree-granting community college in the CUNY system, and the only community college in Manhattan.

The picture of Gabriela was taken at a New York City Museum during one of the visits Stephanie made as an assignment for my class. When Stephanie shared this image with me, I immediately knew it was the perfect cover for this book. It was like looking at an old picture of myself—a little Latina girl awestruck by a work of art and thirsting for more.

REFERENCES

Casey, K. (1995). The new narrative research in education. *Narrative Research, 21*, 211–253.

Freire, P. (2000). *Pedagogy of the oppressed* (30th anniversary ed.). New York: Continuum.

Green, J. (2001, April). *Somatic knowledge: The body as content and methodology in dance and arts education.* Paper presented at the NDEO Conference.

Greene, M. (1995). *Releasing the imagination. Essays on education, the arts, and social change.* San Francisco, CA: Jossey-Bass.

Greene, M. (2001). *Variations on a blue guitar: The Lincoln Center Institute lectures on aesthetic education.* New York: Teachers College Press.

Holzer, M. (2005a). Many layered multiple perspectives: Aesthetic education in teaching for freedom, democracy, and social justice. In N. M. Michelli & D. L. Keiser (Eds.), *Teacher education for democracy and social justice* (pp. 131–148). New York and London: Routledge.

Holzer, M. (2005b). From philosophy to practice: Asking important questions, creating enabling structures. In M. Holzer & S. Noppe-Brandon (Eds.), *Community in the making: Lincoln Center Institute, the arts, and teacher education* (pp. 3–11). New York: Teachers College Press.

hooks, b. (1994). *Teaching to transgress: Education as the practice for freedom.* New York and London: Routledge.

Israel, D., & Kessler, R. (2011, June). The Center for Arts Education. Research & Policy Briefing. *Accelerating arts funding cuts and loss of arts teachers paints grim picture for city schools.* New York: The Center for Arts Education.

Kohler Riessman, C. (1993). *Narrative analysis.* Newbury Park, CA: Sage Publications.

Lazin, L. (Producer). (2003). *Tupac-Resurrection* [Motion picture]. Amaru/MTV and Paramount Entertainment.

Liu, E., & Noppe-Brandon, S. (2009). *Imagination first. Unlocking the power of possibility.* San Francisco, CA: Jossey-Bass.

Maalouf, A. (2000). *In the name of identity: Violence and the need for belonging.* New York: Penguin Books.

McLaren, P. (1998). *Life in schools: An introduction to critical pedagogy in the foundations of education* (3rd ed.). New York: Longman.

McLaren, P. (2003). *Life in schools: An introduction to critical pedagogy in the foundations of education* (4th ed.). Boston: Allyn and Bacon.

Medina, Y., & Shapiro, H. S. (Eds.). (2010). *Schooling in a diverse American society.* New York: Pearson Custom Publishing.

National Center for Education Statistics. (2008). *Education Finance Statistic Center.* Current per-pupil expenditure for public elementary and secondary education in the United States: 2007–2008. Retrieved on January 12, 2012, from http://nces.ed.gov/edfin/graph_topic.asp?INDEX=1

Pennell, A. (2006). Toward compassionate community: What school should be about. In Shapiro, H. S., Latham, K., & Ross, S. (Eds.). *The institution of education*. (5th ed., pp. 35–42). Boston, MA: Pearson Custom Publishing.

Pennell, A. (2010). Toward compassionate community: What school should be about. In Y. Medina & H. S. Shapiro (Eds.), *Schooling in a diverse American society* (pp. 41–48). New York: Pearson Learning Solutions.

Phillips, A. (2003). In the beginning they are babies. In S. Shapiro, S. Harden, & A. Pennell (Eds.), *The institution of education* (4th ed., pp. 203–220). Boston, MA: Pearson Custom Publishing.

Shapiro, S. (1999). *Pedagogy and the politics of the body: A critical praxis*. New York and London: Garland Publishing.

Shapiro, H. S., Latham, K., & Ross, S. (2006). *The institution of education*. (5th ed.). Boston, MA: Pearson Custom Publishing.

Sleeter, C., Gutierrez, W., New, C. A., & Takata, S. R. (1994). On race and education. In S. Shapiro & S. Harden (Eds.), *The institution of education* (3rd ed., pp. 161–169). Boston, MA: Simon & Schuster Custom Publishing.

Stinson, S. (1985). Curriculum and the morality of aesthetics. *Journal of Curriculum Theorizing, 6,* 66–83.

U.S. Department of Education. (2011, March). *Winning the future with education: Responsibility, reform, and results. Oral testimony of U.S. Secretary of Education Arne Duncan.* Retrieved on January 12, 2012, from http://www.ed.gov/news/speeches/winning-future-education-responsibility-reform-and-results

Villaverde, L. E. (2008). *Feminist theories and education*. New York: Peter Lang.

White, B. (2009). *Aesthetics*. New York: Peter Lang.